Postcard History Series

Fairfax County

ON THE FRONT COVER: SEVEN CORNERS MARKET. The Seven Corners area became a major crossroads in 1809, when the Columbia Pike, then called the Washington Graveled Turnpike, intersected with the much-older Leesburg Pike. (Courtesy of Fairfax County Public Library Photographic Archive.)

ON THE BACK COVER: CAMP A. A. HUMPHREYS: IN LINE FOR MESS. A long line waits at the mess hall around World War I. Only four months into Camp A. A. Humphreys's construction in 1918, it was already in heavy use training and preparing soldiers for war. (Courtesy of Fairfax County Public Library Photographic Archive.)

Postcard History Series

Fairfax County

Trevor Owens

Copyright © 2010 by Trevor Owens
ISBN 978-0-7385-6631-3

Published by Arcadia Publishing
Charleston, South Carolina

Printed in the United States of America

Library of Congress Control Number: 2009927055

For all general information contact Arcadia Publishing at:
Telephone 843-853-2070
Fax 843-853-0044
E-mail sales@arcadiapublishing.com
For customer service and orders:
Toll-Free 1-888-313-2665

Visit us on the Internet at www.arcadiapublishing.com

*To my wife Marjee, our two dogs, and the life we
all share in our home in Fairfax County.*

Contents

Acknowledgments 6
Introduction 7
1. Famous Residences 9
2. Military History 37
3. Historic Townscapes 55
4. Recreation 87
5. Places of Worship 113

Acknowledgments

While there is only one name on the spine of this book, the text within would have been impossible without help from members in the Fairfax community. I would like to thank Prof. Randolph Lytton of George Mason University's history and art history department for his thoughts and for allowing me to include cards from his vast collection. I would also like to thank Adam Turner and George Mason University library's special collections department for helping scan and prepare cards from Professor Lytton's collection.

I would like to thank Elaine McHale and the other librarians who helped me navigate the substantial collection of historical materials available in the Fairfax County Public Library's Virginia Room. Without their guidance and the county's commitment to archiving and preserving its historical record, this project would have been much more difficult.

Finally, I would like to thank my wife, Marjee Chmiel. Her help as a constant sounding board, editor, and advisor have been instrumental in this endeavor. Many of the strengths of this book have come from conversations with these members of the Fairfax community.

Introduction

In July 2007, my wife and I purchased our first home in Burke, a community on the southern end of Fairfax County. We moved to the area a year earlier from the Midwest. As history buffs, my wife and I fell in love with the area. Coming from the Midwest, we had never been so close to so many layers of American history. As I worked on my master's degree in American history at George Mason University, my passion for the area grew stronger. I decided to work on this book as a means for me to both further explore my love for the region and share that passion with others.

The history of Fairfax County and the history of its communities have been told many times. Older than the United States itself, Fairfax County was created in 1742. As it's just outside Washington, D.C., Fairfax County has experienced dynamic relationships with the nation's capital. The county has been part of the frontier, a bucolic outpost, the closest enemy stronghold in the Civil War, a suburban hub, and most recently, an economic center of commerce in its own right. There are many ways to understand and approach Fairfax County's history. Exploring it through postcards offers a compelling means to engage with a variety of these themes over the entirety of the county's history.

By presenting postcards created to share, commemorate, and communicate life in the county, this book provides another avenue for understanding its history. The postcards in this collection offer two levels of historical information. On one level, the images in the cards contribute valuable information to the historical record, knowledge about streets, buildings, and parks. On another level, the cards provide information about what county residents, visitors, and business owners thought was significant enough to warrant publishing and saving: what they thought valuable enough to commemorate and share. In short, the cards provide both a record of the past and of what yesterday's residents found significant enough to hold and preserve.

It is important to remember that the postcards in this collection were created for a variety of purposes. Many were sold to tourists at historic sites, like George Washington's Mount Vernon. Other cards were created to advertise local businesses, restaurants, and hotels. Much of the diversity in the presentation and style apparent in this collection of cards stems from the different goals and motivations guiding the card's creators.

The book is divided into five thematic sections. The first chapter, Famous Residences, presents cards showing historic homes of some of the county's most well-known residents. Fairfax County has hosted its share of historic individuals. This chapter includes a variety of cards showcasing the homes of important national and local figures. Many of the homes in this section are open to today's visitors. The second chapter, Military History, focuses on collections of cards sold to soldiers at Fort Belvoir. Fairfax County has played a vital role in the nation's military history. The county was the site of several decisive Civil War battles and has been home to leading army training facilities for the past 100 years. The third chapter, Historic Townscapes, provides scenes of the county's built environment, local businesses, transportation projects, and public

buildings. The last 150 years have witnessed the landscape of Fairfax County transformed from remote outskirts into a dynamic, bustling set of connected communities with over 1,000,000 people. This section presents a history of that transformation through views of the county's roads, railroads, and businesses. The fifth chapter, Recreation, presents cards sold to tourists. It includes a collection of cards from Great Falls National Park and a diverse selection of cards from camps, hotels, and motels. The final chapter, Places of Worship, presents cards created to commemorate the county's many churches. Some of Fairfax County's oldest structures are places of worship. This chapter provides a history of various church communities and the cards those communities created as a celebration and commemoration. Each chapter contributes to an overall understanding to the county's history.

The organizing themes behind the chapters emerged as the most compelling means to present the collection. While one could organize these cards chronologically or geographically, presenting them in this thematic fashion affords several benefits to readers. First, it allows readers to follow their own particular interests and explore the themes in the county's history that they find most interesting. Second, it allows for comparisons and juxtapositions between postcards focused on the same subject matter across time, within a specific area.

Throughout the book, readers will find small captions accompanying the collection of cards. For the most part, the captions attempt to provide a context for the cards—connecting the images presented in the postcards to the history of Fairfax County. Many of the captions also provide analysis of the cards—suggesting ways to think about and understand the implications of the cards in relation to the broader history of the county. Over the course of the book, the captions contribute to an overall approach to understanding Fairfax. Each caption aspires to offer interesting facts related to the individual cards. The goal behind writing the captions in this fashion is to provide value to different kinds of readers. Both readers who choose to read the book straight through and casual readers who occasionally leaf through the book, pausing to read the captions only for cards that they find particularly interesting, should find value in the captions.

Over the course of working on this project, I have learned quite a bit about the history of Fairfax County. Many of the places, parks, businesses, historic homes, and sites profiled in this volume are open to visitors. For readers who have not spent much time exploring the history of the county, I hope the book can provide a starting point to further explore its fascinating history.

Unless otherwise noted, all cards in the volume appear courtesy of the Fairfax County Public Library Photographic Archive. The other cards come courtesy of the Randolph H. Lytton Historical Postcards of Fairfax, Virginia, collection maintained by George Mason University's library department of special collections.

One

FAMOUS RESIDENCES

Fairfax County has hosted its share of historic individuals. This section includes a variety of cards showcasing the homes of important national and local figures. Many of the homes in this section are open to today's visitors. The residences in this chapter appear, roughly, in chronological order. The chapter begins with significant coverage of the plantations of founding fathers George Washington, Richard Bland, and George Mason, as well as the plantation of Washington's nephew. The chapter ends with a selection of residences of local and area lawyers, doctors, and politicians from the late 19th and early 20th centuries.

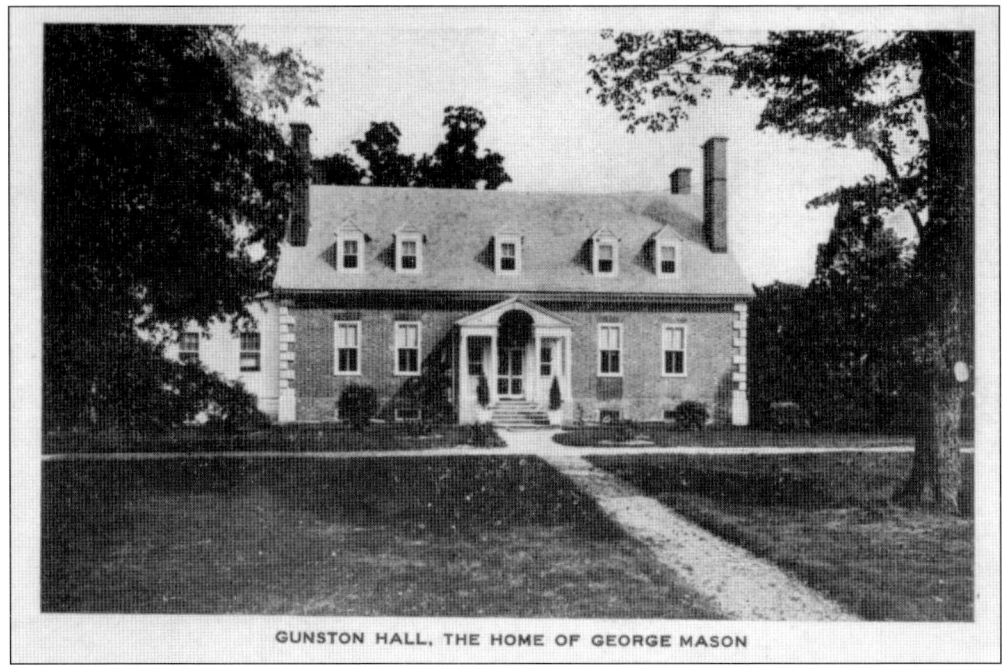
GUNSTON HALL, THE HOME OF GEORGE MASON

GUNSTON HALL, HOME OF GEORGE MASON. Built between 1755 and 1759, Gunston Hall was the home of founding father George Mason. Mason served as a delegate from Virginia to the Constitutional Convention. His work on the Virginia Declaration of Rights provided a model for the Bill of Rights. William Buckland, an indentured servant who worked for George Mason, designed the home. The house is an excellent example of Georgian-style architecture and has had a significant impact on design in the area. For example, notice the engineering buildings at Fort Belvoir. Gunston Hall was located at the center of Mason's 5,500-acre plantation overlooking the Potomac.

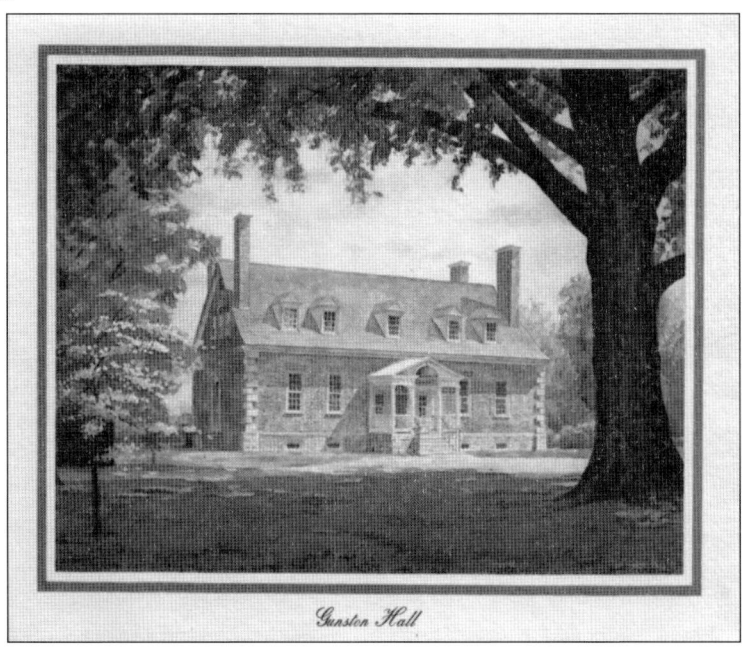
Gunston Hall

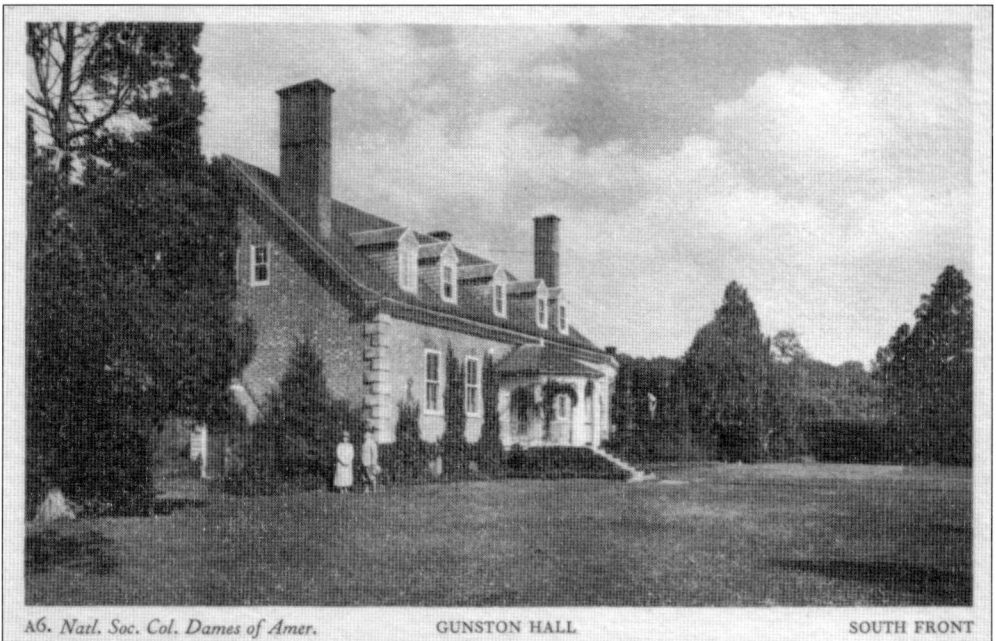

A6. *Natl. Soc. Col. Dames of Amer.* GUNSTON HALL SOUTH FRONT

GUNSTON HALL FRONT. In 1932, Virginia formally accepted Gunston Hall and the surrounding grounds from Louis Hertle. Louis's wife, Eleanor Hertle, wanted the home to be a memorial to George Mason. In 1952, the home was opened to the public. The residence was designated as a U.S. National Historic Landmark in 1960 and added to the U.S. National Register of Historic Places in 1966. The site remains a popular tourist destination. With the exception of Thanksgiving, Christmas, and New Year's Day, Gunston Hall is open every day. Visitors can take guided tours of the home starting every half hour.

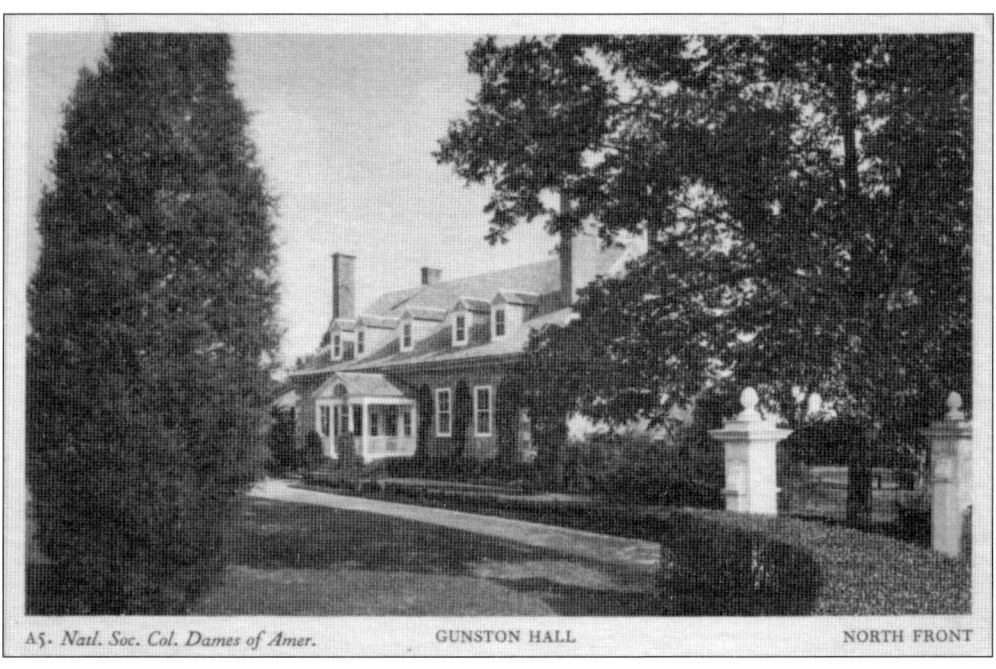

A5. *Natl. Soc. Col. Dames of Amer.* GUNSTON HALL NORTH FRONT

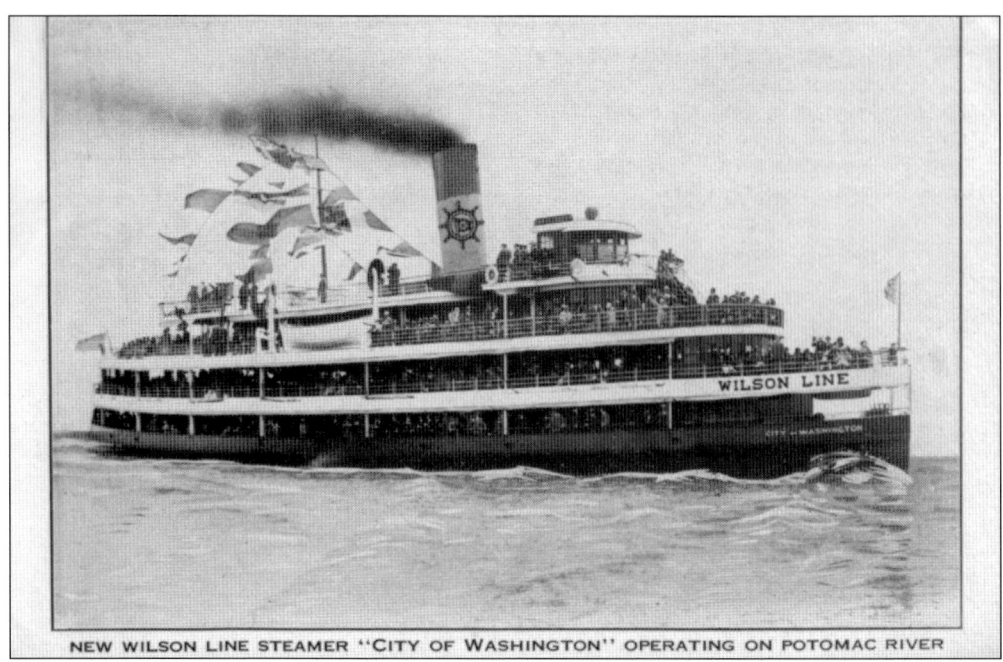

NEW WILSON LINE STEAMER "CITY OF WASHINGTON" OPERATING ON POTOMAC RIVER

STEAMBOATS ON THE POTOMAC. These two cards show examples of the many steamboats that traveled along the Potomac. The first card shows the *City of Washington*. Over the later half of the 19th century through the early part of the 20th, the *City of Washington* carried passengers to all points south of Washington, D.C., on the Potomac. The second card shows either the *Charles Macalester* or the *River Queen* docked in front of George Washington's home, Mount Vernon. In the 1880s, the Mount Vernon and Marshall Hall Steamboat Company ran these steamboats between Washington, Alexandria, Mount Vernon, and Marshall Hall. At the time, $1 would cover the round-trip fare and the price of admission to Mount Vernon.

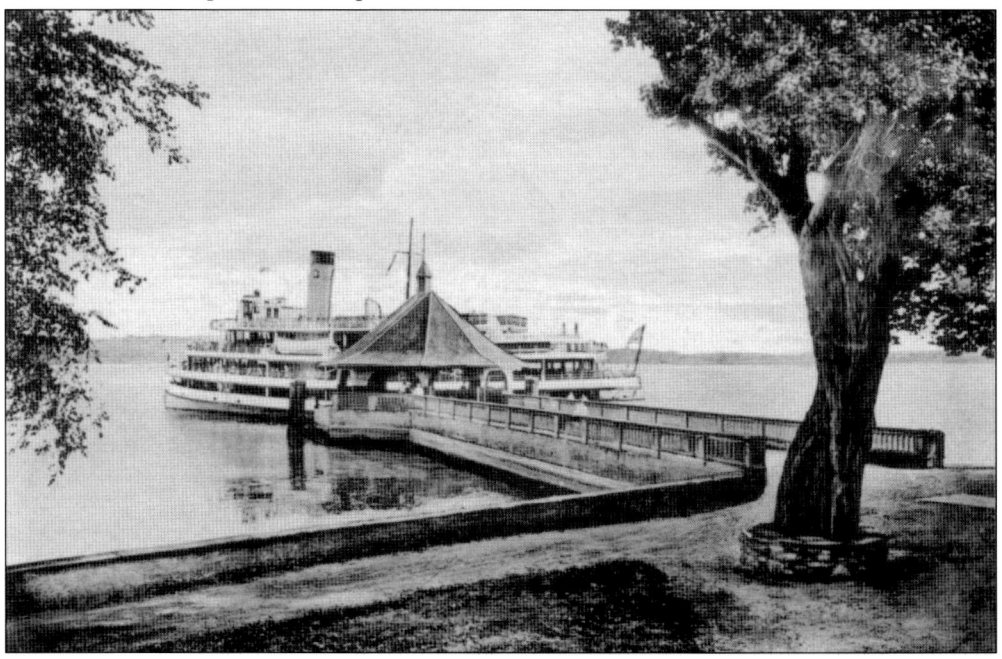

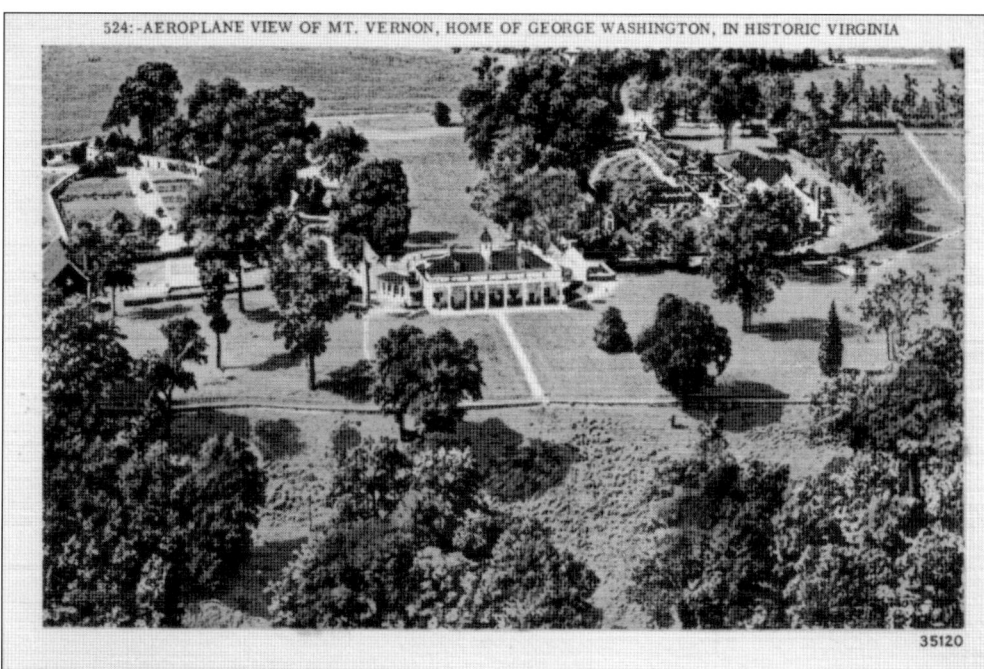

EXTERIOR FACING THE POTOMAC. Home to George Washington for more than 45 years, Mount Vernon is one of the most popular tourist destinations in the county. Washington's grandfather originally obtained the property in 1674. George Washington inherited the property in 1761. The aerial view of the estate provides a view of the home in relation to the outbuildings and gardens. The second card shows the building's exterior facing the Potomac. When Washington lived at Mount Vernon, the residence and farm pictured here was one of five farms that made up the 8,000-acre plantation. At the time, this farm was referred to as the Mansion Farm.

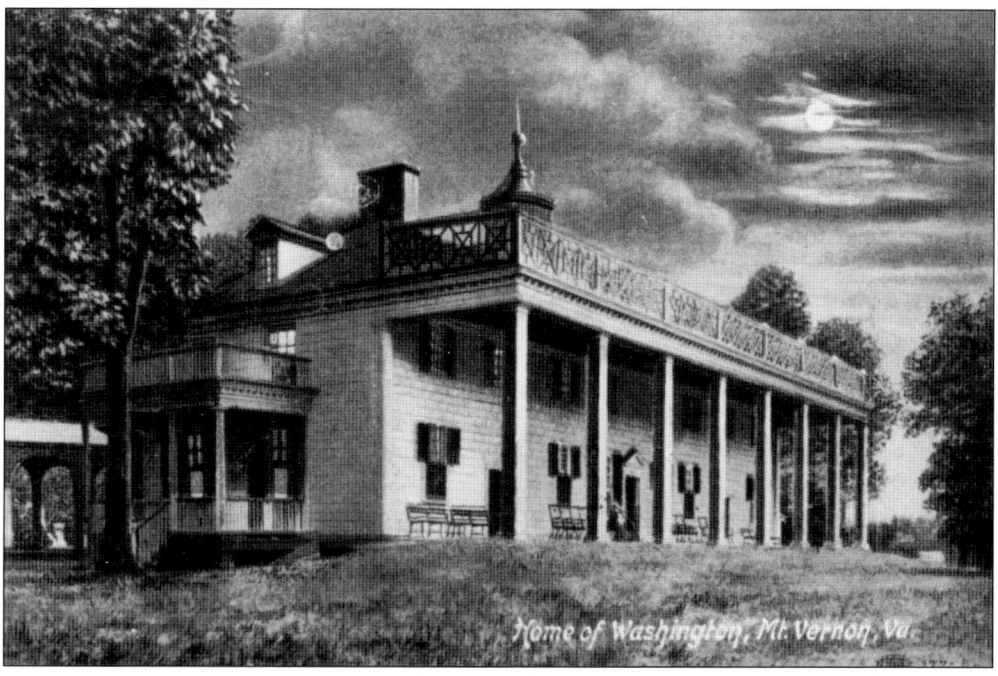

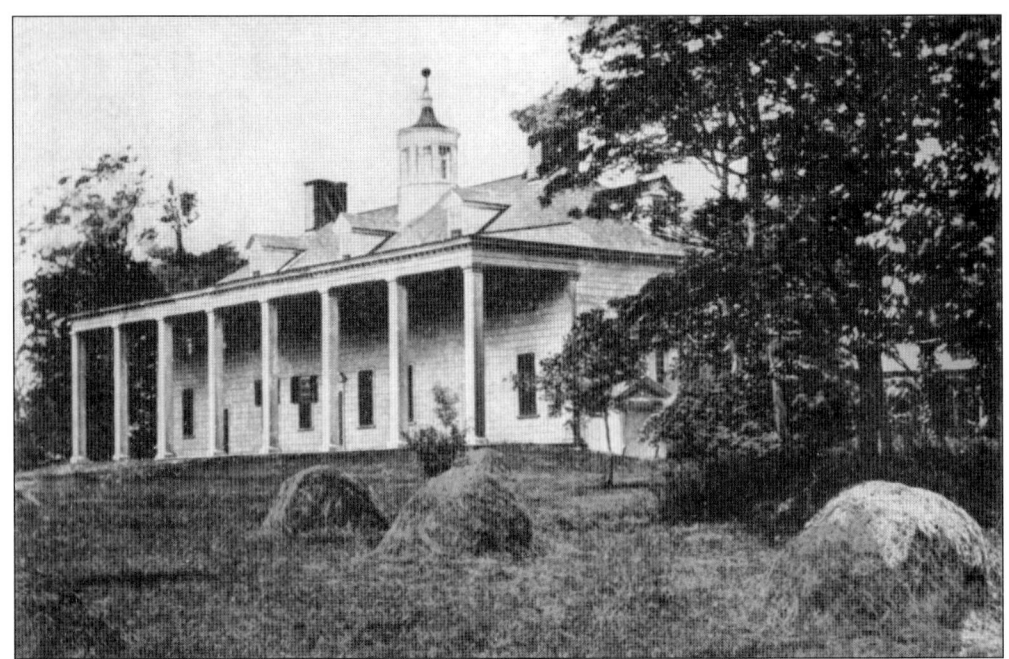

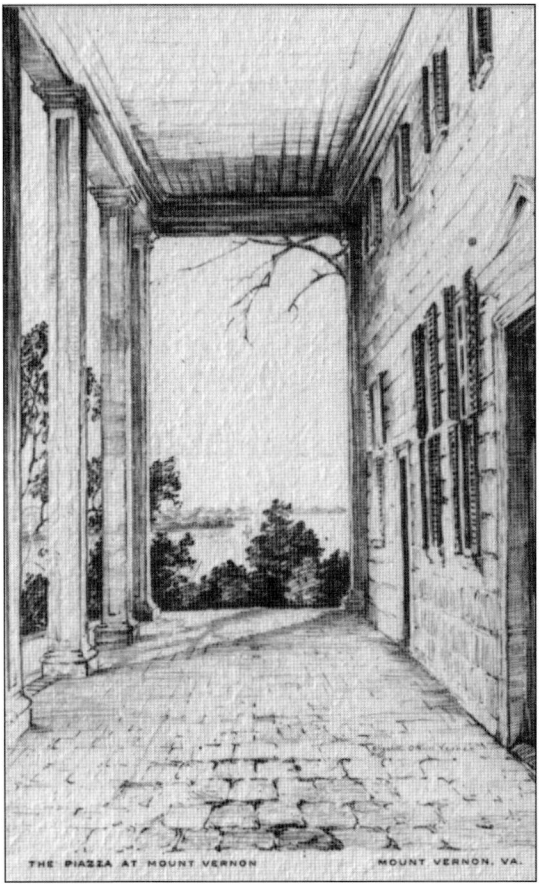

MOUNT VERNON'S PIAZZA. These cards present Mount Vernon's signature, and often imitated, two-story piazza. The floor of the piazza is paved with white flagstones. Eight wooden piers support the piazza's low-pitch roof. Washington added the piazza to the mansion in 1777. By the 1850s, it had fallen into disrepair. The Mount Vernon Ladies Association replaced the original in 1860. Over the course of American history, the piazza has been grafted onto all manner of homes and commercial buildings. Copied from building to building, placed on the most expensive and inexpensive homes around the nation, the piazza has become a democratic form in American architecture.

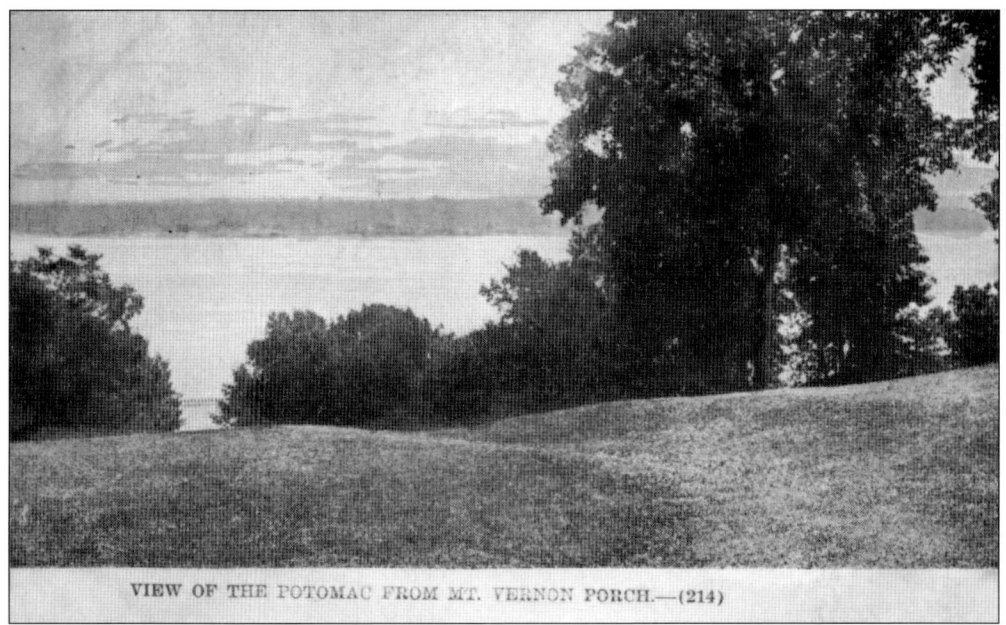

VIEW OF THE POTOMAC FROM MT. VERNON PORCH.—(214)

VIEW OF THE POTOMAC FROM MOUNT VERNON. This postcard presents a view from the piazza looking southwest toward the Potomac River. The piazza takes advantage of the elevated position of the home and its position on the Potomac to offer breathtaking panoramic views of the river. Collectively, this card and the next provide a sense of the unforgettable view the piazza affords.

NORTH SIDE OF MOUNT VERNON. This card offers a view of the north side of the house. The large window brings light into the two-story dining room. This large dining room was the final addition Washington made to the mansion. Work on the room began in 1774 and was not completed until 1788.

15

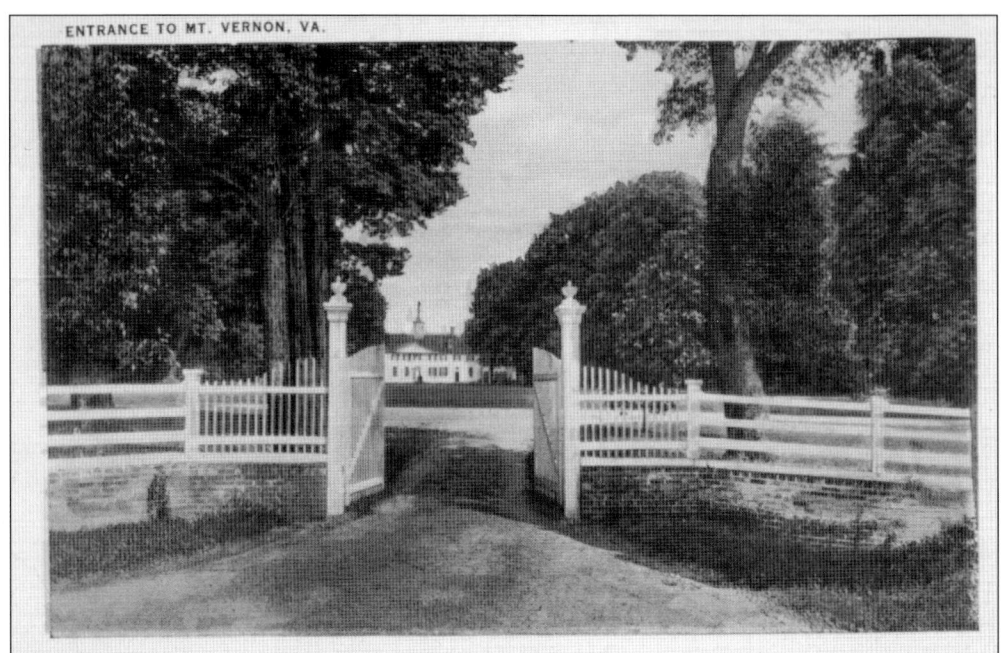

APPROACHING MOUNT VERNON. Here one can see a view of the mansion through the gates from the northwest. The perspective of this image offers a sense of the scale of the estate. When George Washington inherited the plantation it consisted of 2,000 acres. Over the course of his life, he expanded it by approximately 8,000 acres. Visitors to the mansion today pass through these gates to see it appearing much as it does in the second card. When Washington inherited the property, this house was considerably smaller. Among Washington's many additions to the residence, he raised the roof to add another story, added pine blocks coated with paint and sand to give the home the appearance of a stone exterior, and added the decorative cupola to the roof.

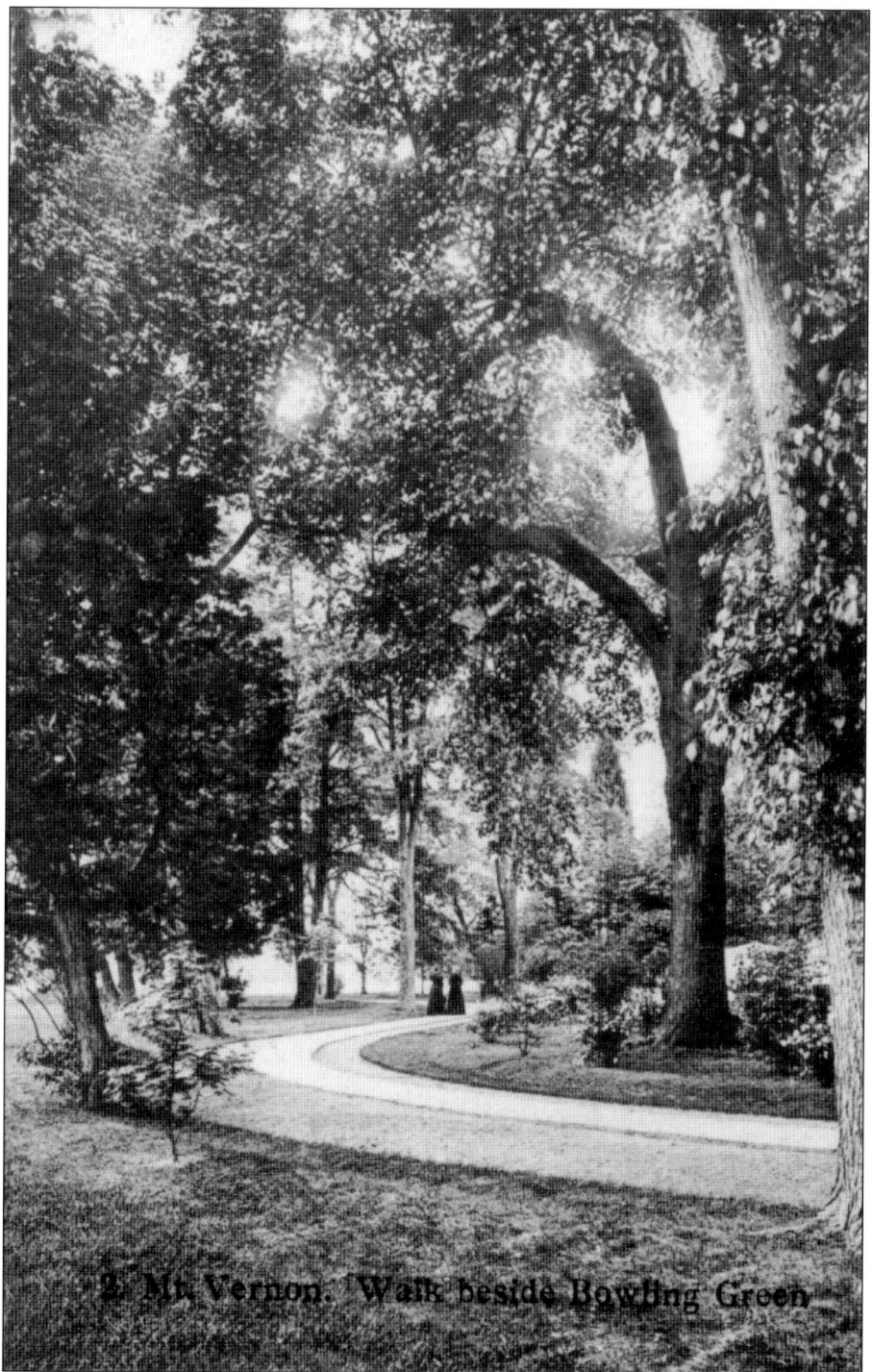

THE MOUNT VERNON ESTATE. This card illustrates the serene, rolling estate which has greeted visitors to Mount Vernon for more than 200 years. Much of the property features winding paths through vibrant greenery. Planning the estate not only involved planning the building but the surrounding environment as well.

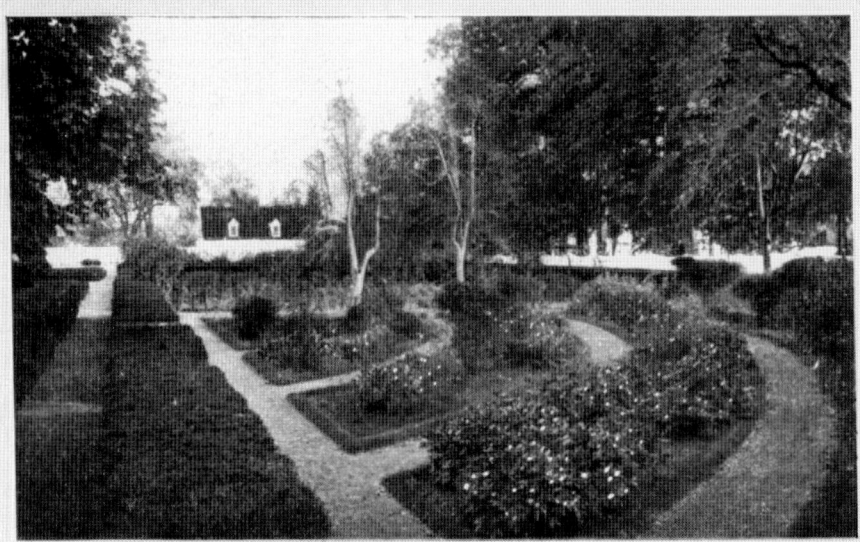

MT. VERNON GARDEN.

MOUNT VERNON UPPER GARDEN. This card presents Mount Vernon's upper garden. In this garden, Washington grew hollyhocks, peonies, primroses, heliotrope, and larkspur, among many other plants. Fig and flowering cherry trees and century-old boxwood hedges can also be found. The garden has a distinctive boxwood parterre shaped as a fleur-de-lis.

NELLY CUSTIS'S SCHOOL HOUSE. This small, octagonal, one-room building can be found in the upper garden. It is believed that it was used as a schoolhouse for Martha Washington's grandchildren and George Washington's step-grandchildren, Eleanor Parke Custis Lewis and George Washington Parke Custis. The grandchildren were affectionately referred to as Nelly and Wash. Eleanor Parke Custis married George Washington's nephew, Lawrence Lewis. They lived much of their lives at Woodlawn plantation. Eleanor viewed herself as preserver of George Washington's legacy. George Washington Parke Custis became a well-known orator and playwright. He lived much of his life in his home, Arlington House. Arlington House was eventually given to his son-in-law, Robert E. Lee. The home is now the Robert. E. Lee Memorial in Arlington National Cemetery.

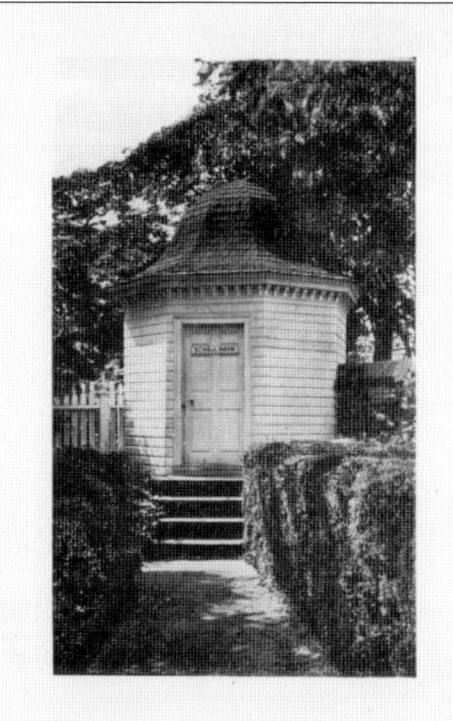

SCHOOL HOUSE, MT. VERNON GARDEN.

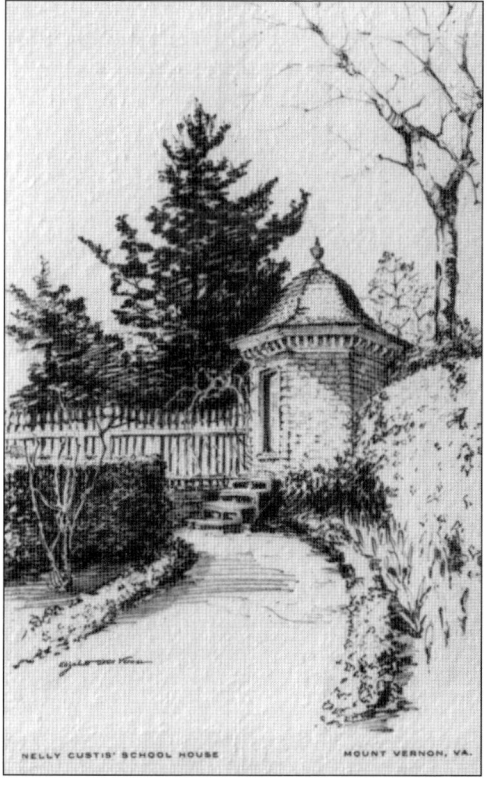

NELLY CUSTIS' SCHOOL HOUSE — MOUNT VERNON, VA.

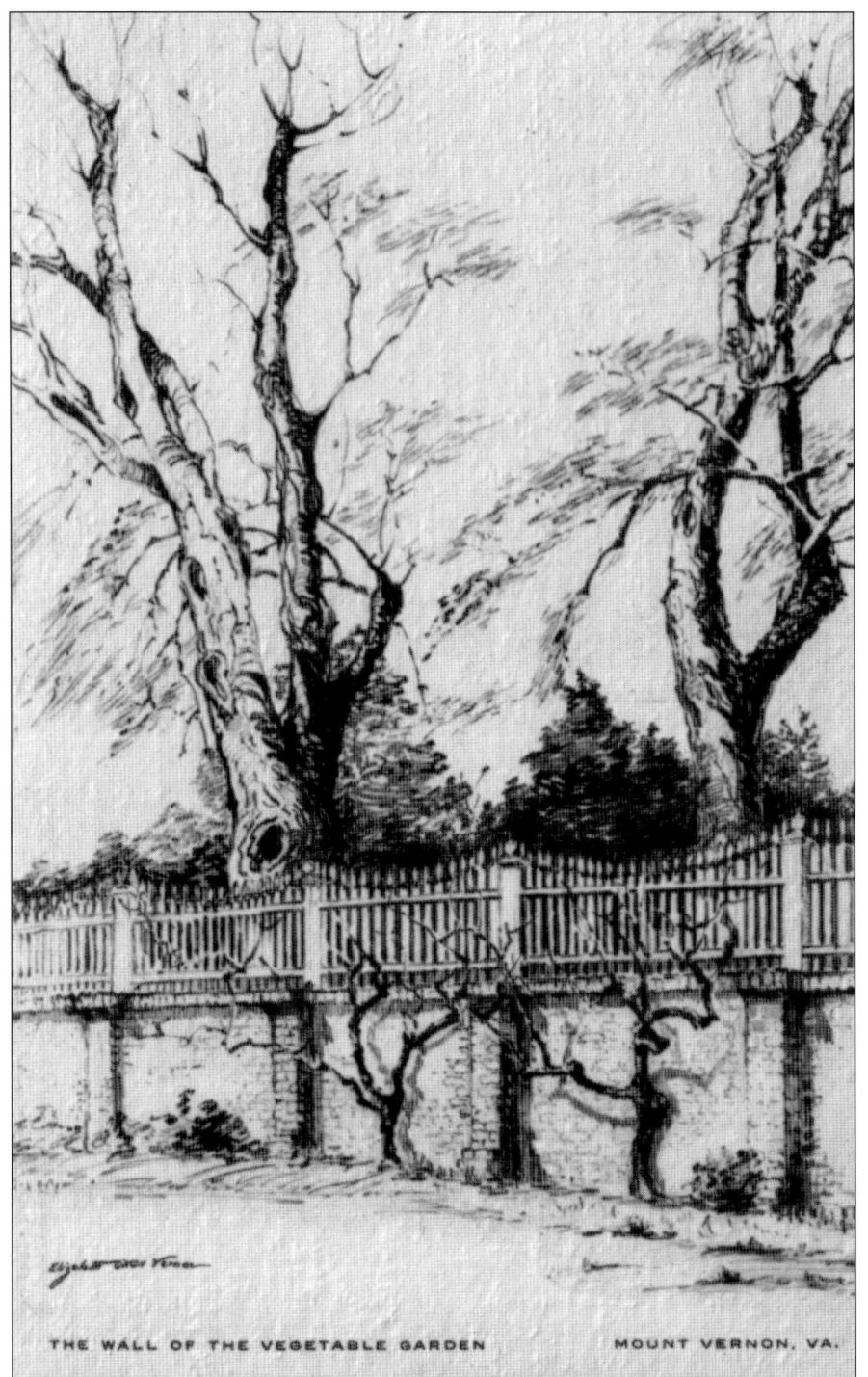

MOUNT VERNON, WALL OF VEGETABLE GARDEN. This card shows a view of the gardens at Mount Vernon. Based on the drawing, it is difficult to know exactly which part of the walled garden appears in this photograph. In contrast to the upper garden, Washington's lower garden was filled with kitchen crops like peas, spinach, asparagus, and beans.

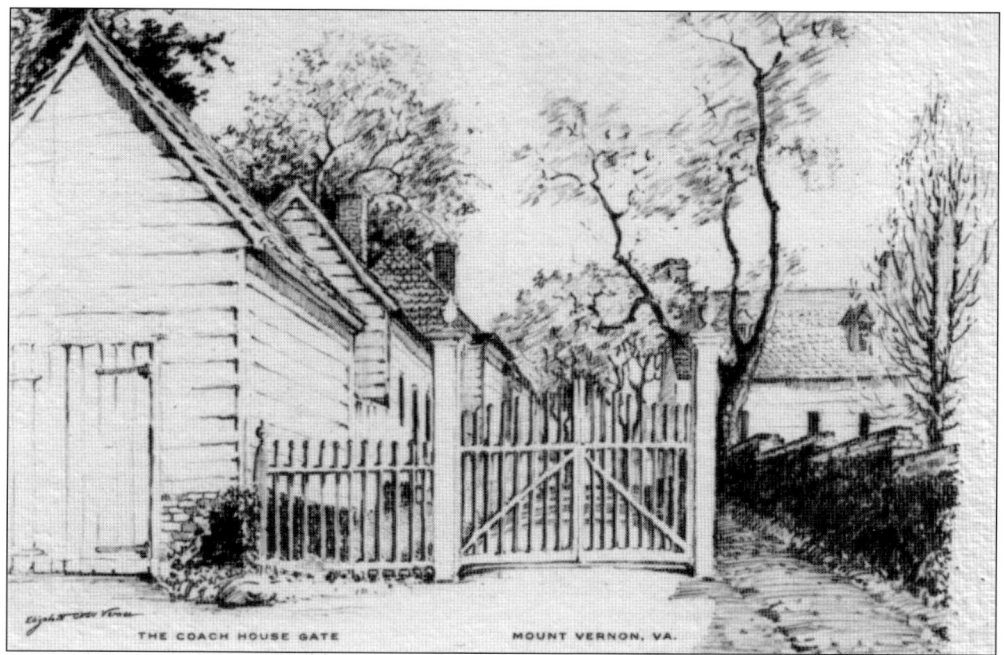

MOUNT VERNON, COACH HOUSE. The coach house held several of Washington's horse-drawn vehicles, none of which remain today. The house held a large carriage, which would have been drawn by four to six horses. It also contained a riding chair, a two-wheeled vehicle that maneuvered much more elegantly along the country roads surrounding the estate.

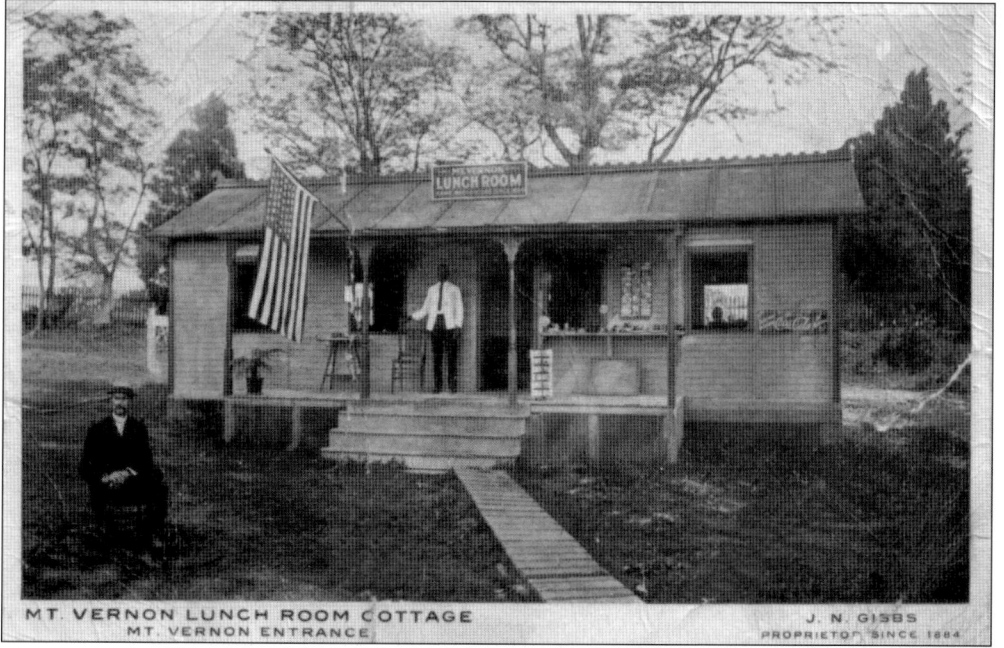

MOUNT VERNON CONCESSION STAND. This concession stand was established—with permission from the Mount Vernon Ladies Association—by Joseph Gibbs in 1884. The concession stand operated from 1884 until the 1920s. The card stands as a clear reminder of just how long the home has been a tourist attraction.

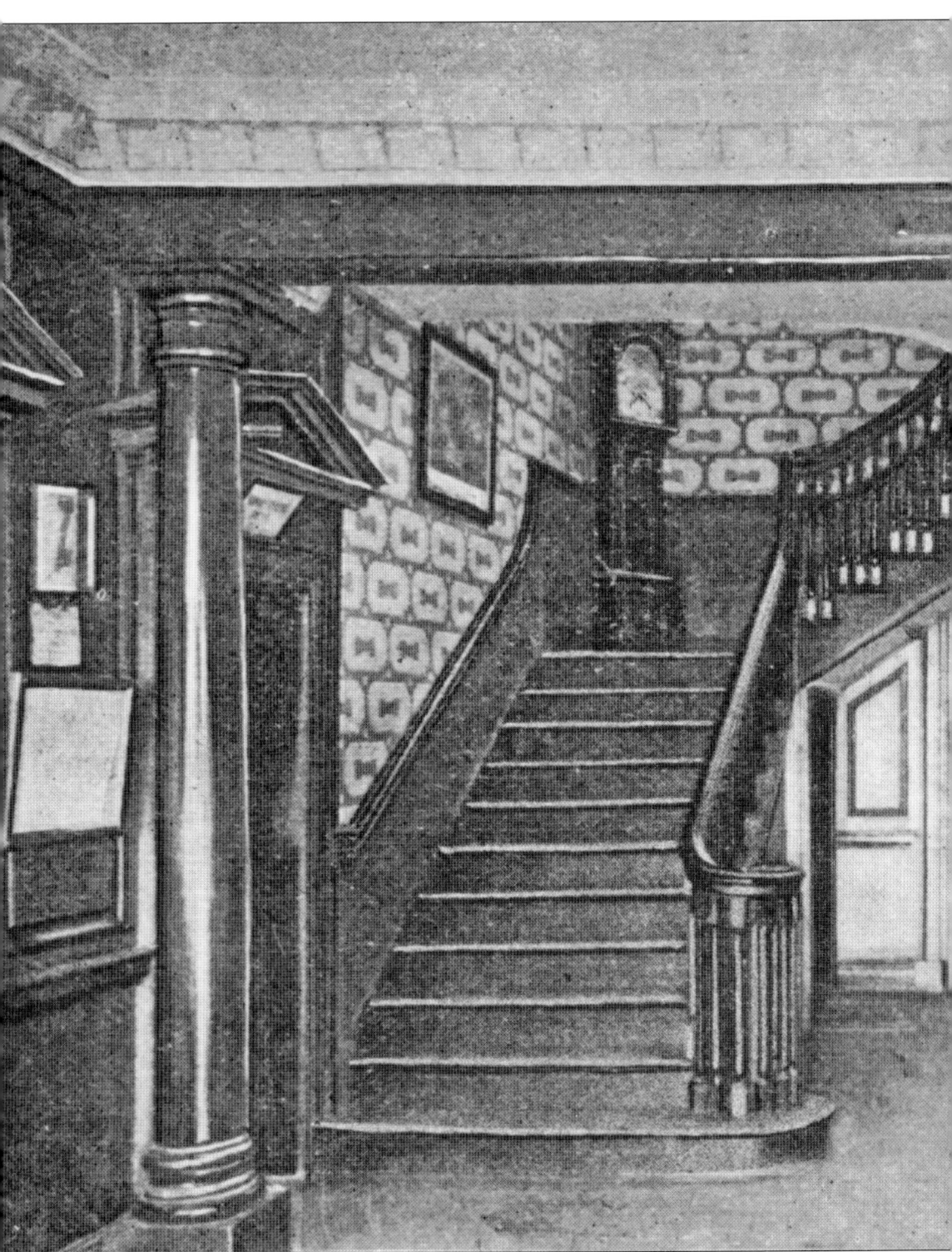

MAIN HALL, MOUNT VERNON. This central passageway functioned as the primary setting for entertaining guests. The room runs the full width of the residence. Washington added the large

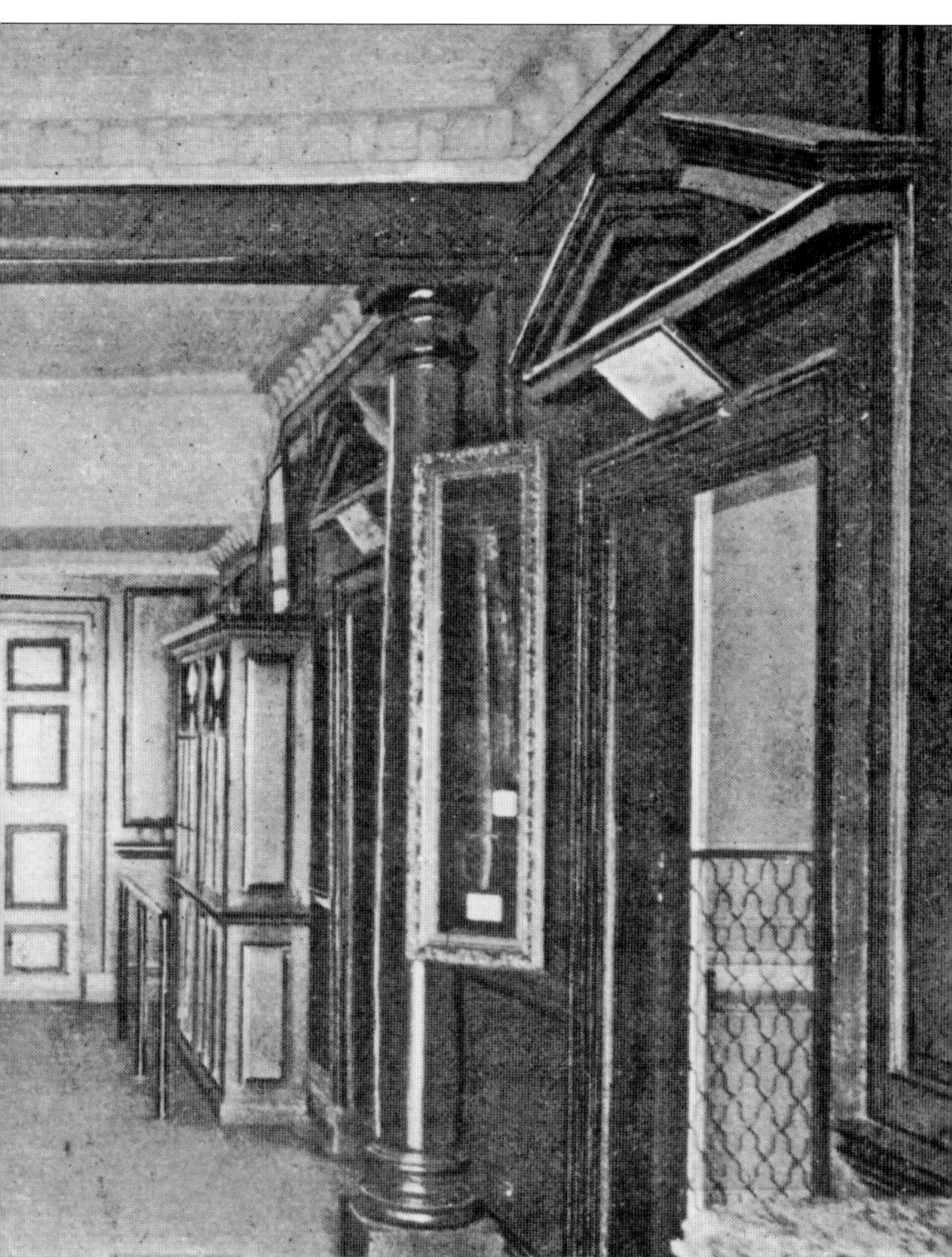
walnut staircase in 1757. At that time, he also installed pine paneling, which he later had painted to imitate mahogany.

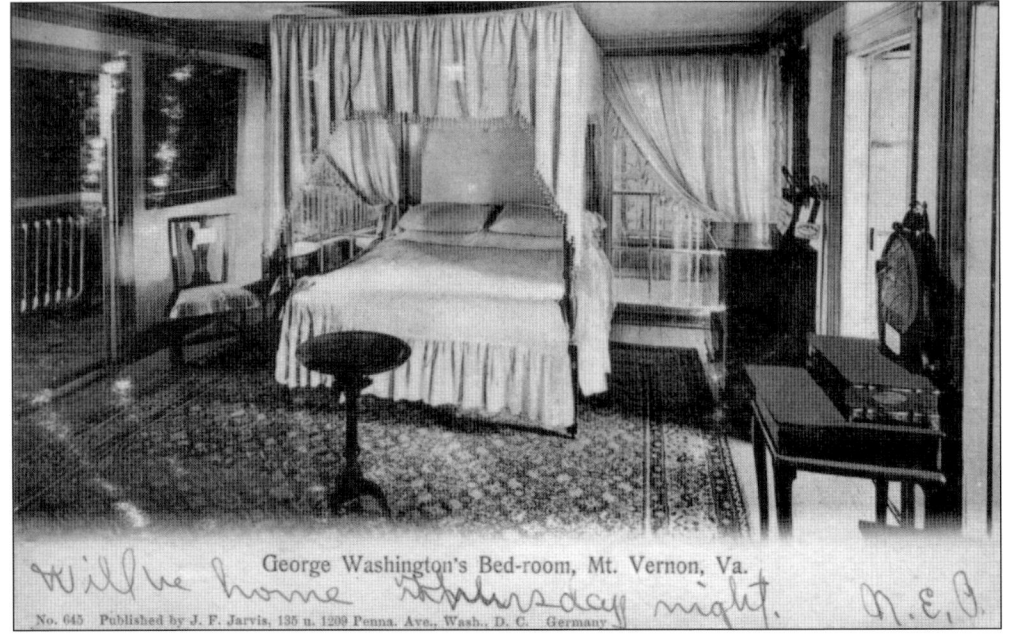

GEORGE WASHINGTON'S BED-ROOM. The master bedroom of the Washingtons is located on the second floor, above the study. On December 14, 1799, George Washington died from a throat infection in this room. After his death, Martha Washington moved to a bedroom on the third floor. Like the rest of the house, the Mount Vernon Ladies Association has attempted to re-create what the house looked like in the late 1700s.

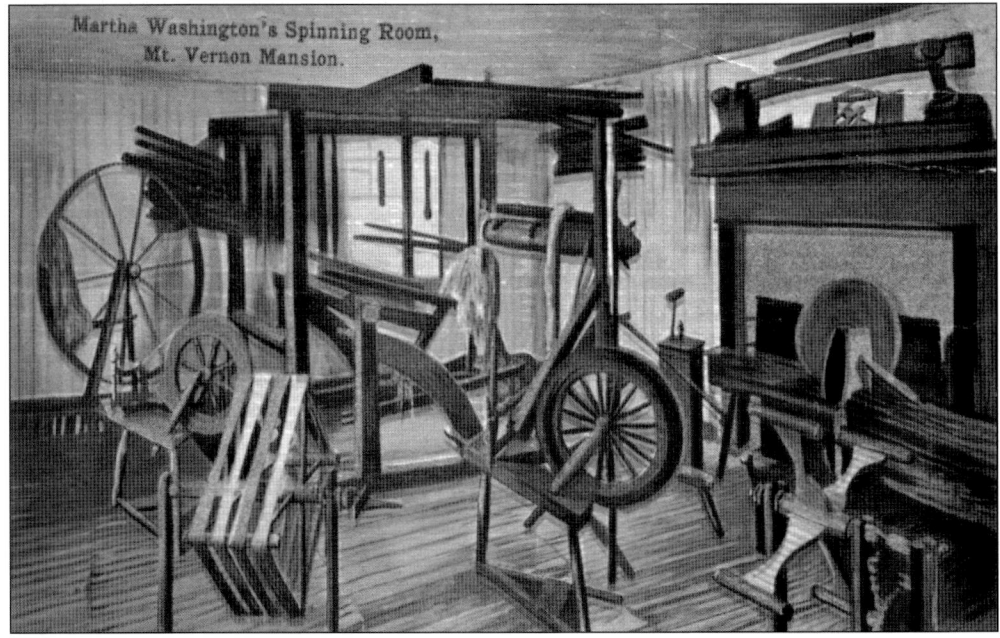

MARTHA WASHINGTON'S SPINNING ROOM. In the spinning room, enslaved spinners worked raw fibers of flax and hemp to make linen and rope. Most of the raw materials were grown on-site at Mount Vernon. While Mount Vernon was quite self-sufficient, Washington did need to import materials for finer clothing from abroad.

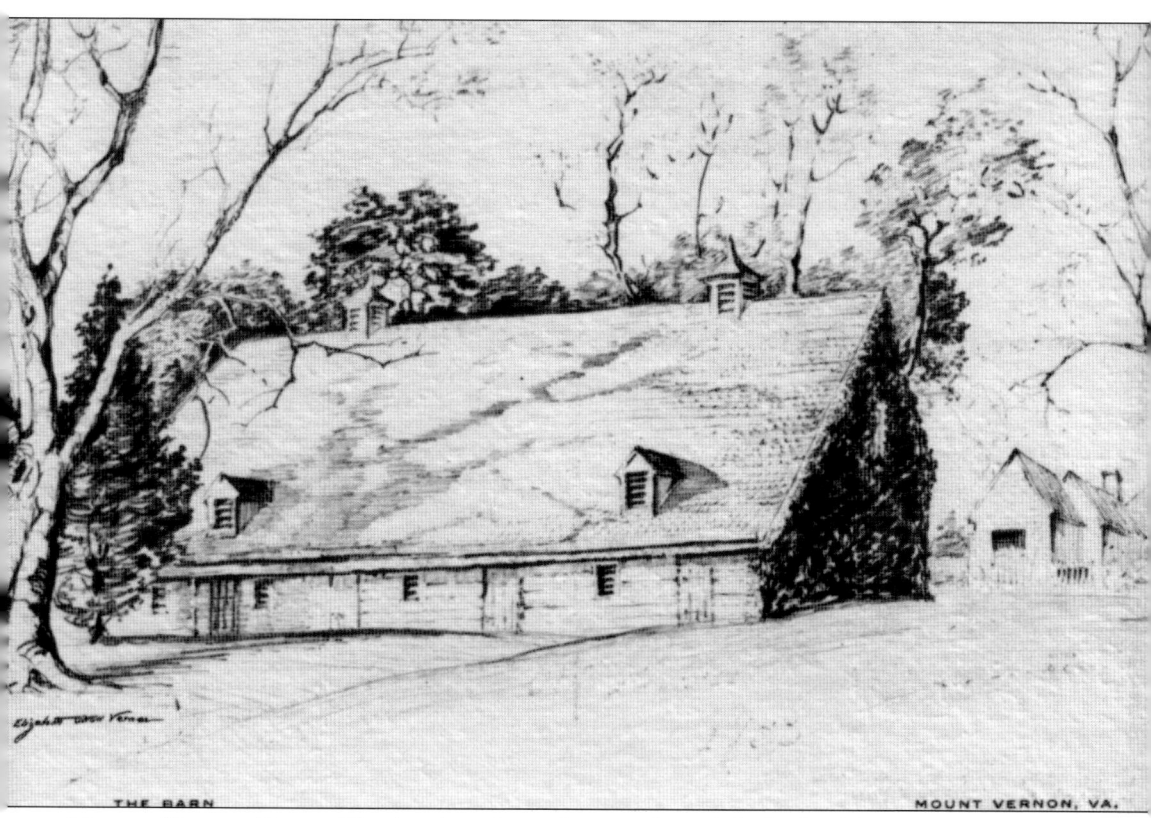

Mount Vernon Barn. The drawing above shows a view of the back of the stables at Mount Vernon. In Washington's time, Peter Hardiman, a slave, managed the stables. The horses kept here were used not only for transportation but also for racing and fox hunting. Washington was known to be an excellent horseman, and he spent time training his own horses.

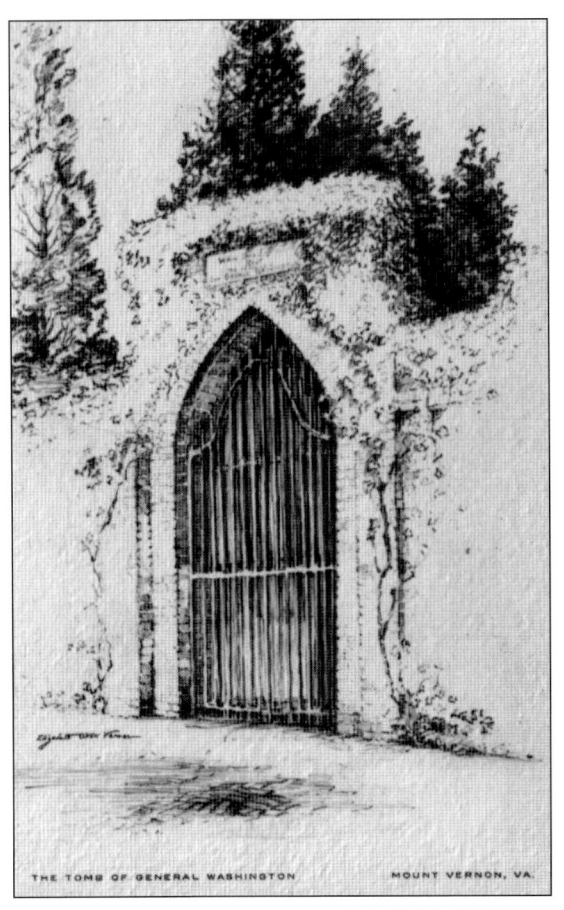

THE TOMB OF GENERAL WASHINGTON. Washington's will stipulated that a new brick family tomb be constructed "at the foot of what is commonly called the Vineyard Inclosure." He was initially entombed in an existing, but deteriorating, family vault. Following an 1831 attempt to rob the vault, the new tomb, shown in these postcards, was completed. The remains of Washington, his wife, and other family members are all kept here. On a nearby hill is an unmarked cemetery for the slaves who worked on the estate. Before Washington's death, there were plans to bury him in the U.S. Capitol building. The crypt below the Capitol Rotunda was initially designed for this purpose. However, Washington was buried at his home according to his wishes in his will.

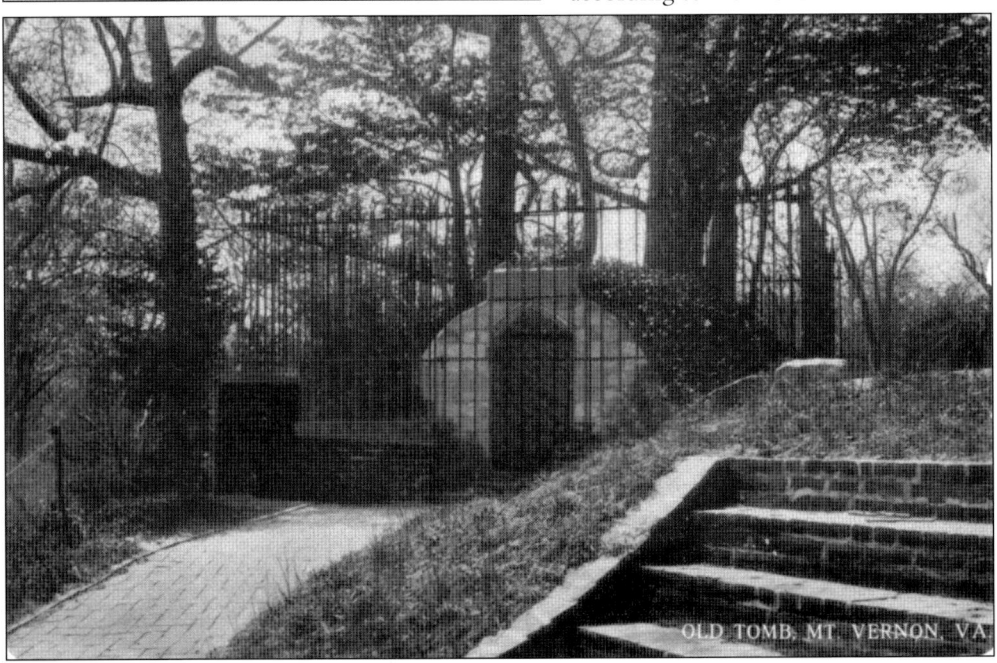

WOODLAWN PLANTATION EXTERIOR. Built between 1800 and 1805, Woodlawn plantation was the home of Maj. Lawrence Lewis and his wife, Eleanor "Nelly" Custis Lewis. The home was built on 2,000 acres of land, which George Washington gave the couple as a wedding gift. Major Lewis was George Washington's nephew, and Nelly was Martha Washington's granddaughter. William Thornton, famous for designing the U.S. Capitol, designed the home.

WOODLAWN PLANTATION GROUNDS. Here one can see a view of the plantation grounds. In 1846, the Lewises' son sold the home to two Quaker families who established the property as a "free labor colony." They broke the property into lots, which they sold to both blacks and whites. The grounds shown in this image are the Garden Club of Virginia's attempt to reconstruct designs typical of this sort of plantation at the time of its first construction.

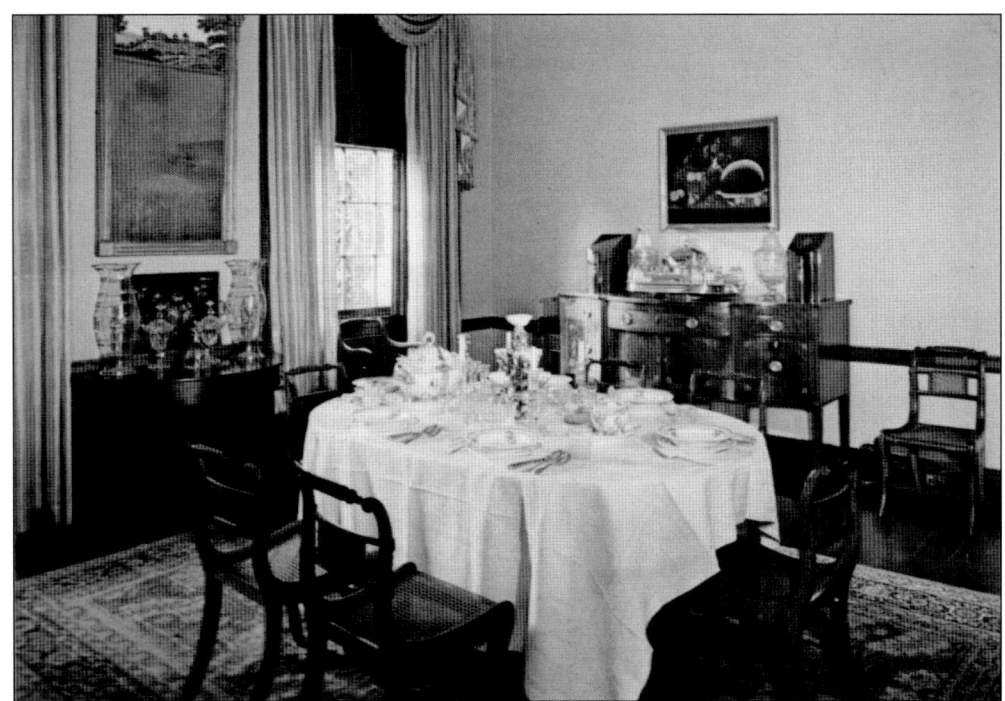

WOODLAWN PLANTATION DINING ROOM. This card presents a view of the dining room at Woodlawn plantation. By the 20th century, the residence had fallen into disrepair. Throughout the first half of the century, the home was transferred between several different private owners, some of whom attempted to restore the home. In 1952, the plantation became the first historic site owned by the National Trust for Historic Preservation.

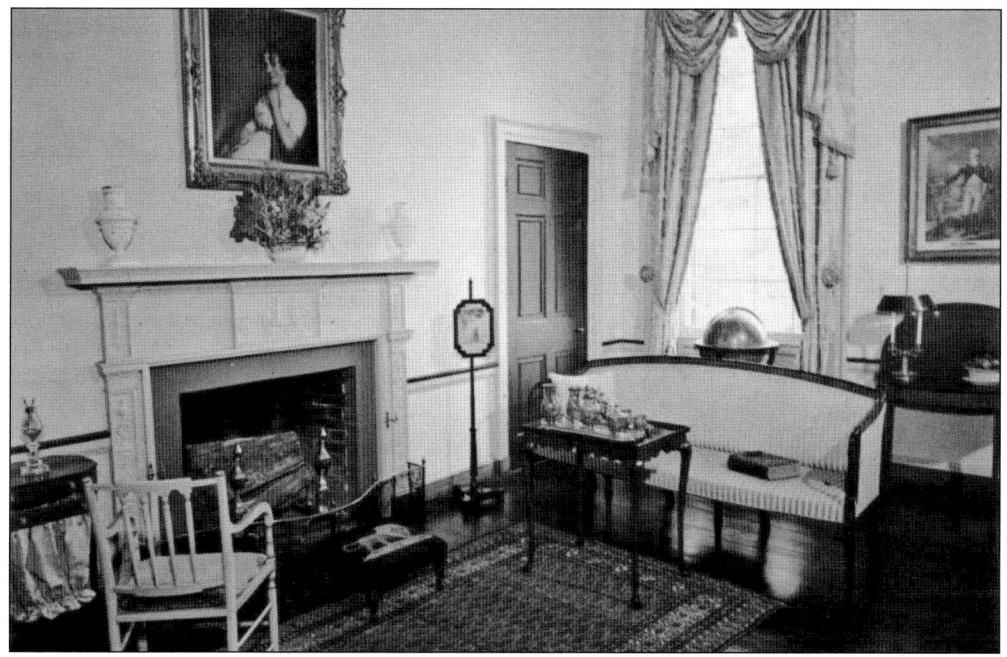

WOODLAWN PLANTATION SITTING ROOM. The sitting room provided a space for the Lewises to entertain. This room has several artifacts related to the family. The Bristol vases belonged to Nelly Custis, as well as the footstool, which is covered with her needlework. Above the mantel, one can see a copy of the Stuart portrait of Nelly Custis.

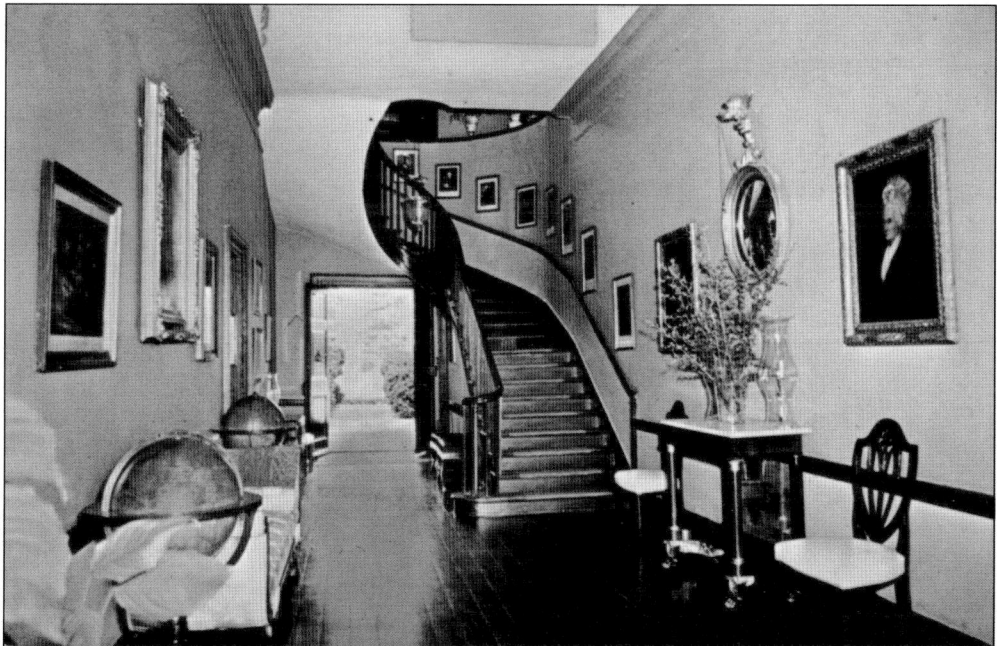

WOODLAWN PLANTATION HALL. Similar to Gunston Hall and Mount Vernon, Woodlawn plantation has a large central hallway with a prominent staircase that cuts across the middle of the home. The house now operates as a museum. Visitors take a guided tour of the home, which is open April through December, Thursdays through Mondays.

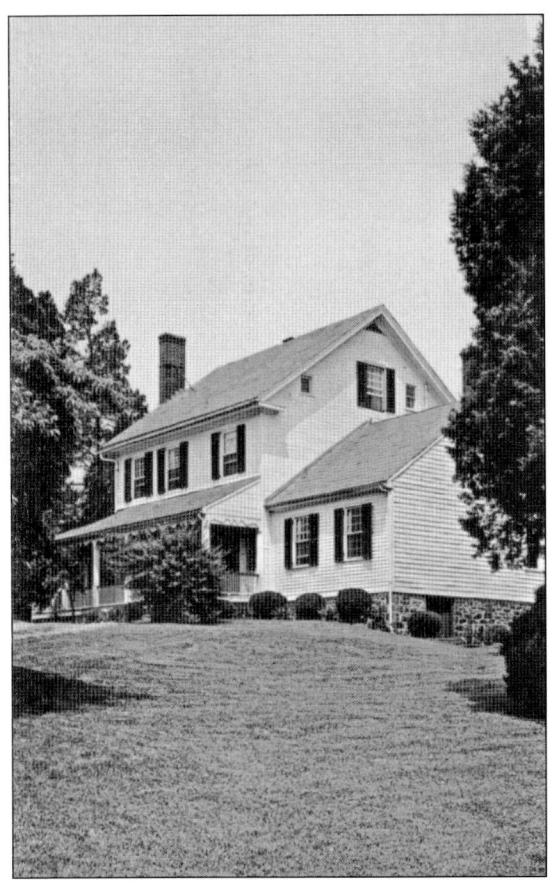

SULLY PLANTATION. Richard Bland built Sully Plantation for his wife, Elizabeth Collins Lee, in 1794. Bland is most famous for serving as Northern Virginia's first representative in the U.S. Congress and as the uncle of Robert. E. Lee. At the time, the home was situated on a 3,111-acre tract of land, then part of Loudoun County. The building can now be found just south of Dulles International Airport on Sully Road. The historic site is now on the Register of Historic Places and offers tours of both the residence and its outbuildings. Visitors to the site can take guided tours that explore the life of the Lee family, the tenant farmers, and slaves, who lived on the plantation.

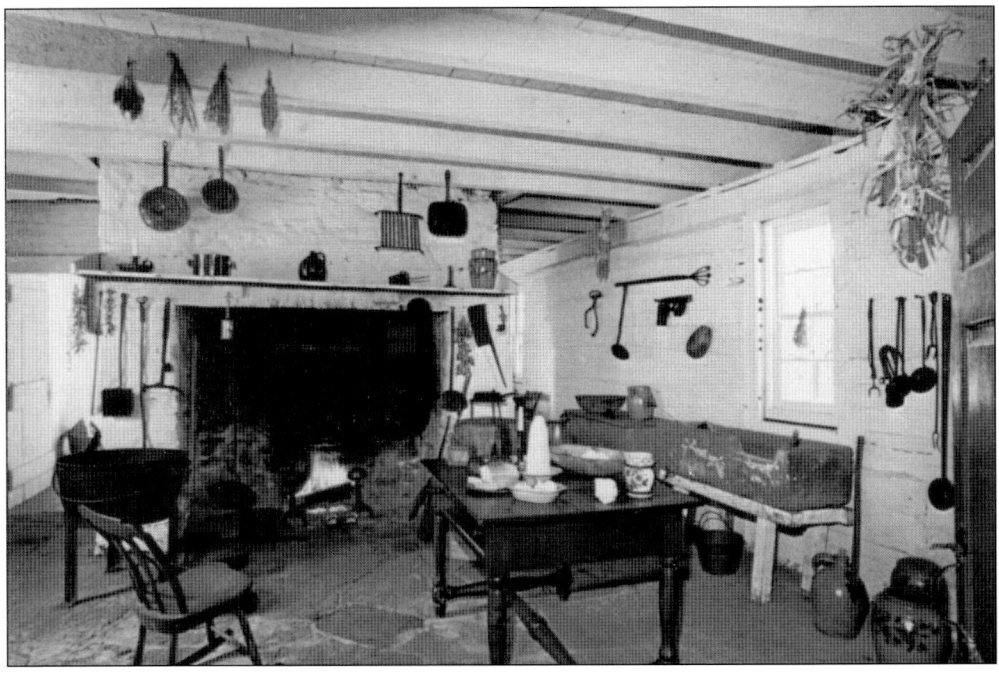

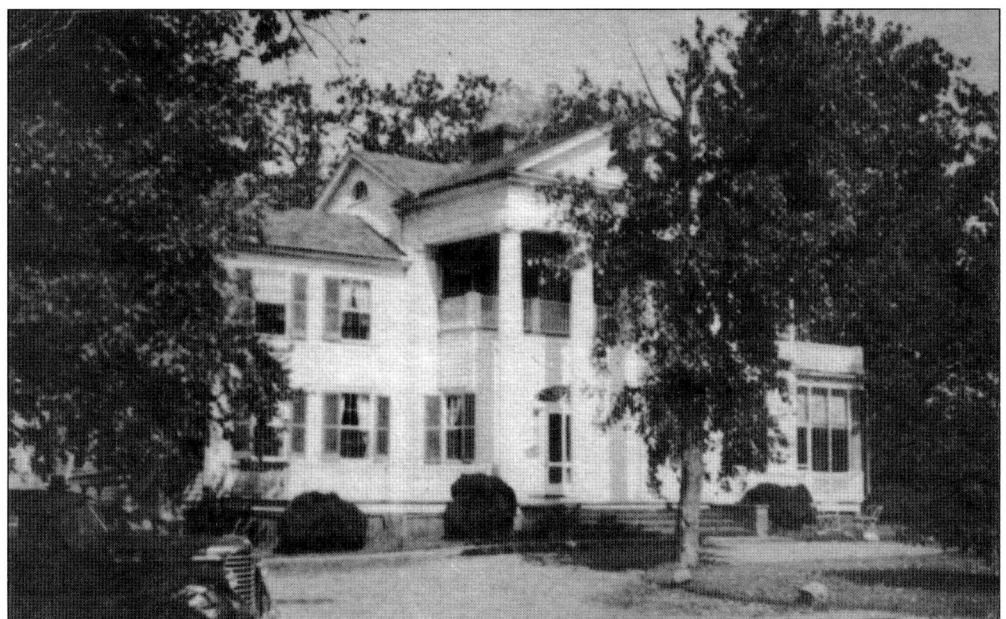

COLLINGWOOD. Generally referred to as the "River Farm," the property was established in 1653 by Giles Brent and his wife, a princess of the Piscataway tribe. Located just north of Mount Vernon, the property was purchased by George Washington in 1760. The building is now the headquarters for the American Horticultural Society. The society's garden is open Monday through Friday, except national holidays, without charge.

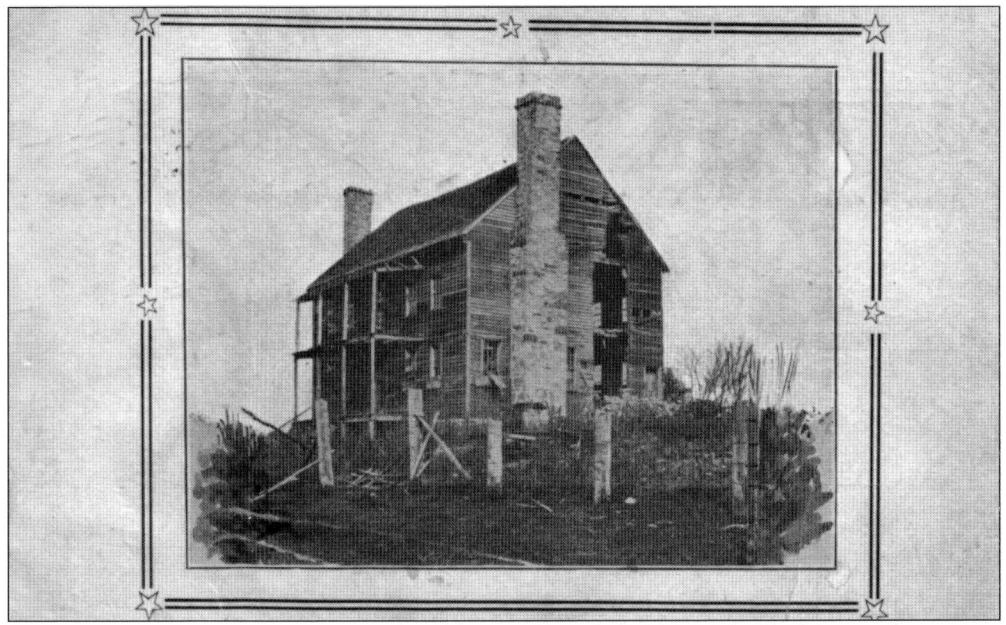

GRIGSBY HOUSE, C. 1904. This postcard shows the home of slave-dealer Alexander P. Grigsby of Centerville. The house served as headquarters for Gen. Joseph Johnston, commander of the Army of Northern Virginia. His army provided the primary Confederate military presence in the eastern theater of the Civil War. In 1862, as the Union retook the area, the home became headquarters for Union general John Pope.

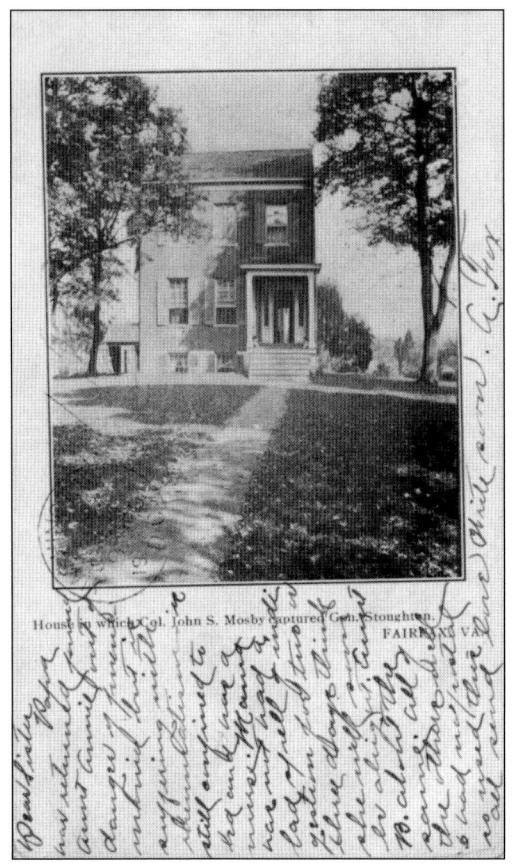

THE EPISCOPAL RECTORY. These two cards show the same building presented to two audiences. Before the Civil War, the building served as the rectory for a nearby Episcopal church. The first card commemorates this use. The second card commemorates a Confederate victory that occurred in the same building. In March 1863, Confederate colonel John S. Mosby captured three high-ranking Union officers inside this building. According to popular accounts, Mosby surprised Brig. Gen. Edwin H. Stoughton as he slept in this house. Allegedly, Mosby snuck up and slapped Stoughton in bed. After being rudely awakened, General Stoughton shouted, "Do you know who I am?" to which Mosby replied, "Do you know Mosby, General?" "Yes! Have you got the rascal?" "No, but he has got you!" The building is currently referred to as the W. P. Gunnell House and is a private residence in Old Town Fairfax.

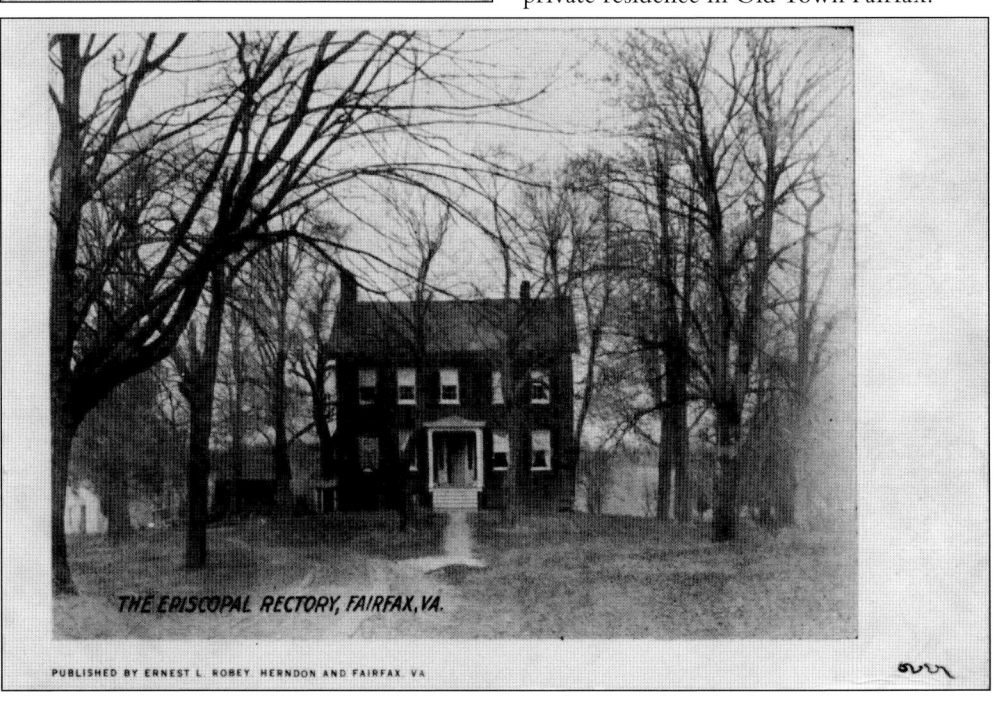

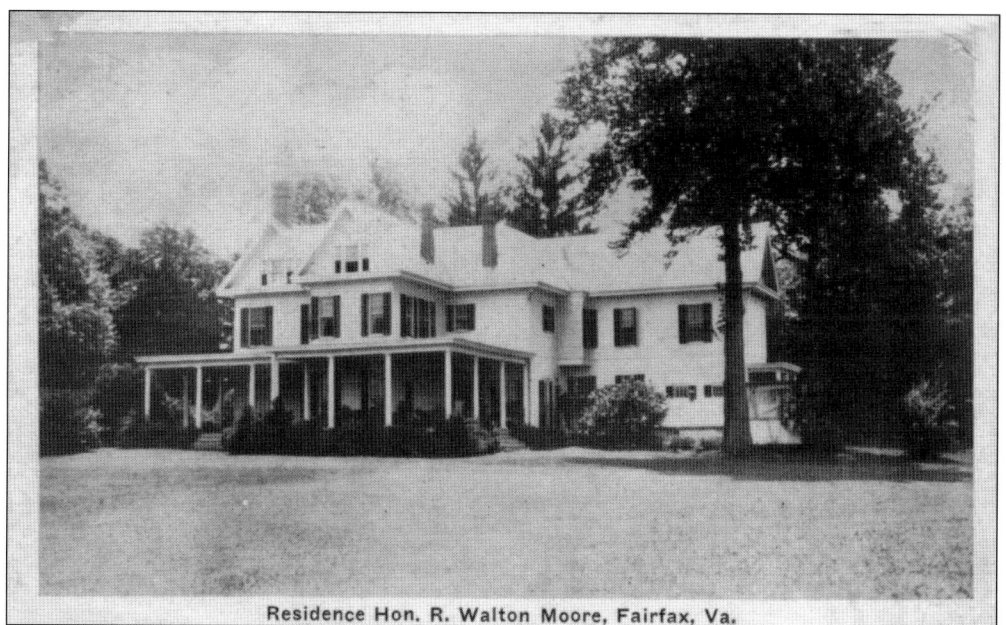

RESIDENCE HON. R. WALTON MOORE. This card shows the home of Robert Walton Moore (1859–1941). Robert Moore served in various public roles in the commonwealth of Virginia and the federal government. He was elected as a Democrat to Congress in 1910 and served six terms. After serving in Congress, he was appointed assistant secretary of State by Pres. Franklin D. Roosevelt.

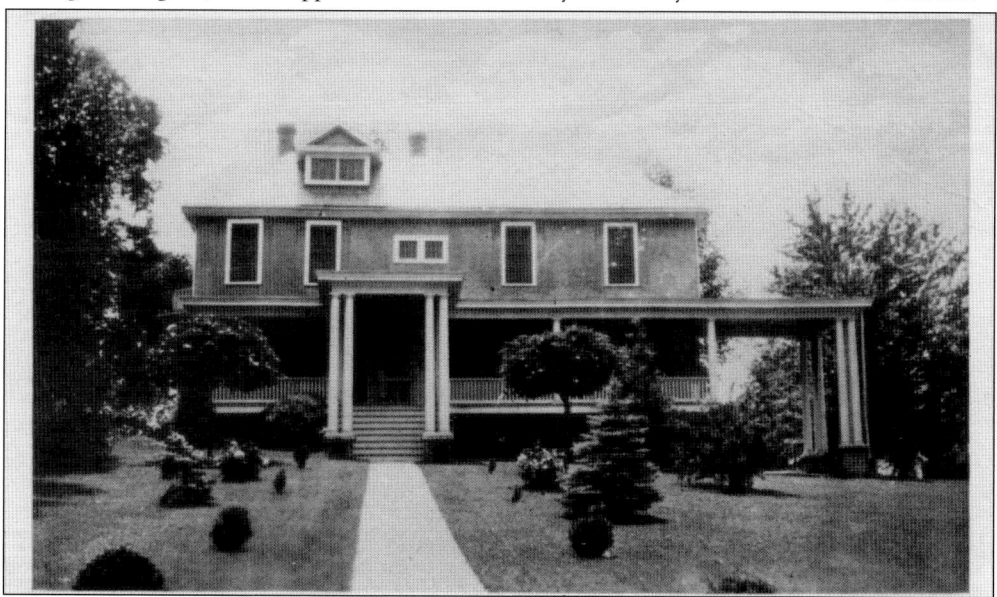

RESIDENCE OF JOHN W. RUST. This card shows the home of Virginia state senator John W. Rust. The Rust family has been active in local and commonwealth politics for more than 100 years. John W. Rust's son, John H. Rust, served as the mayor of the city of Fairfax in 1941. After serving as mayor, he served on and off as the city's attorney until 1974. His son, John H. Rust Jr., practices law in Fairfax with the firm Rust and Rust. John H. Rust Jr. has also worked for historic preservation in the city of Fairfax as the Chairman of the History of the City of Fairfax Round Table.

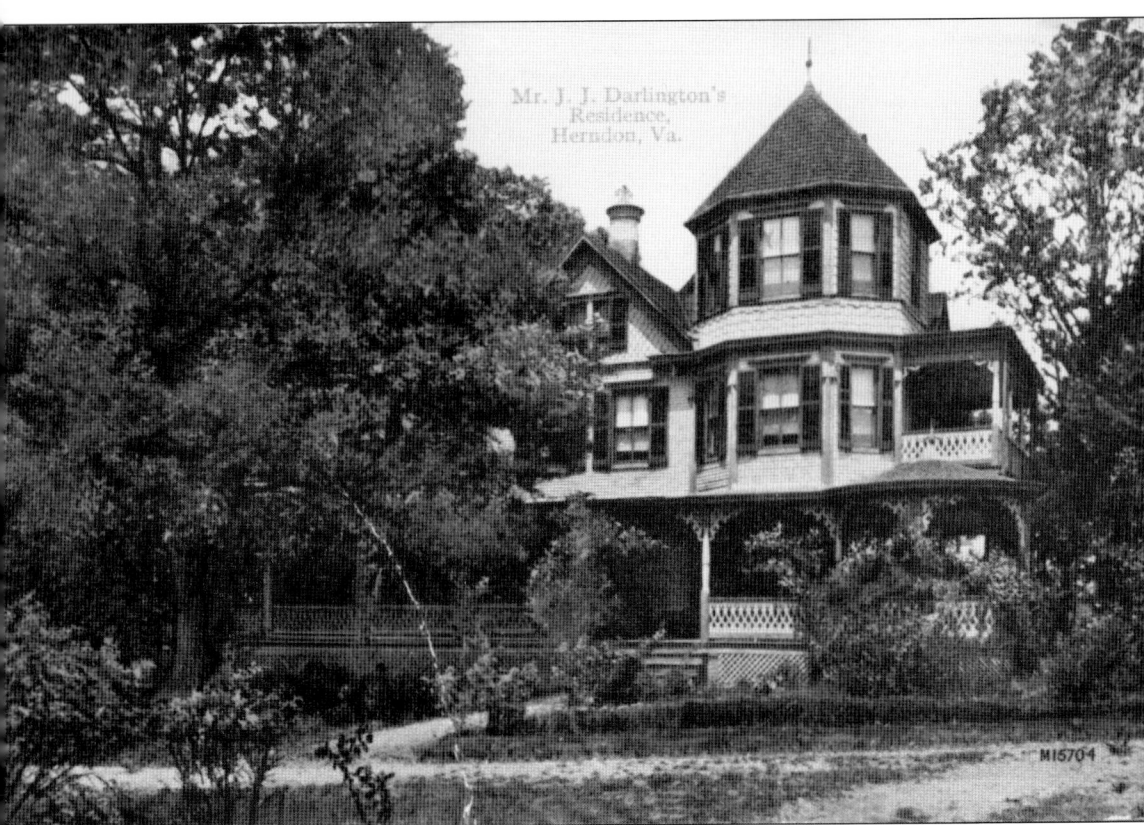

Mr. J. J. Darlington's Residence, Herndon. At the beginning of the 20th century, the city of Herndon began actively promoting itself as a summer getaway to escape the heat of Washington, D.C. This postcard of wealthy D.C. lawyer Joseph J. Darlington's residence in Herndon is evidence of the Herndon's success at marketing itself as a place for D.C. residents to get away. The home was located in downtown Herndon, roughly on the current location of the Angeethi Indian Cuisine restaurant.

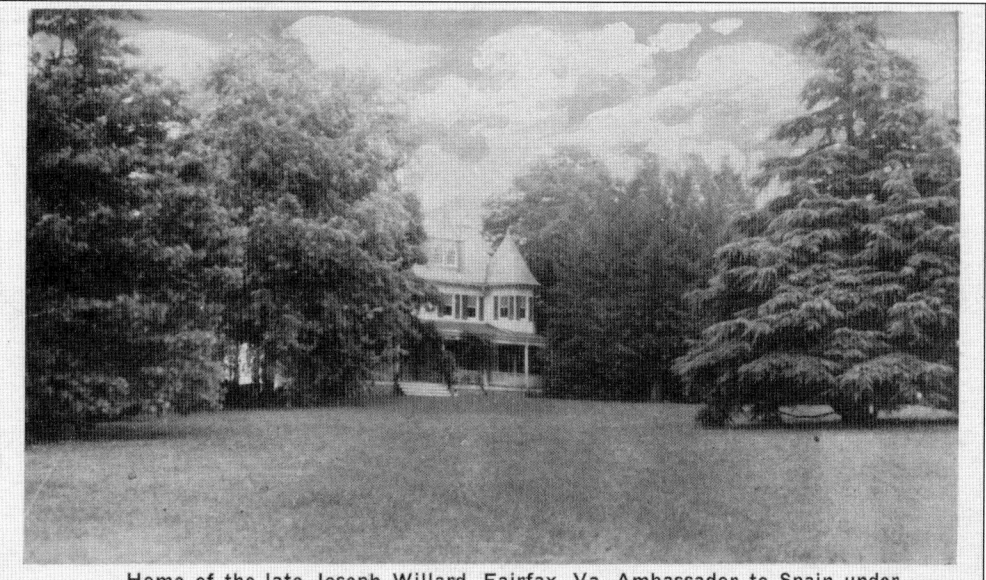

Home of the late Joseph Willard, Fairfax, Va. Ambassador to Spain under Wilson Administration

COL. JOSEPH WILLARD'S RESIDENCE. These cards present the home of Joseph Edward Willard. Born in 1865, Willard became one of the most influential political figures in the country's history. He served in the Virginia House of Delegates from 1896 until 1902. He then served as the lieutenant governor of Virginia until 1906. He left his position as lieutenant governor after an unsuccessful run for governor. From 1906 until 1910, he worked to regulate utilities, insurance companies, and railroads as a commissioner for the Virginia State Corporation Commission. In 1900, Willard financed the construction of Old Town Hall in what would eventually become know as the city of Fairfax. In 1913, Woodrow Wilson appointed Willard the U.S. ambassador to Spain. He held that position for the next 10 years. (Above courtesy of the Randolph H. Lytton Historical Postcards of Fairfax.)

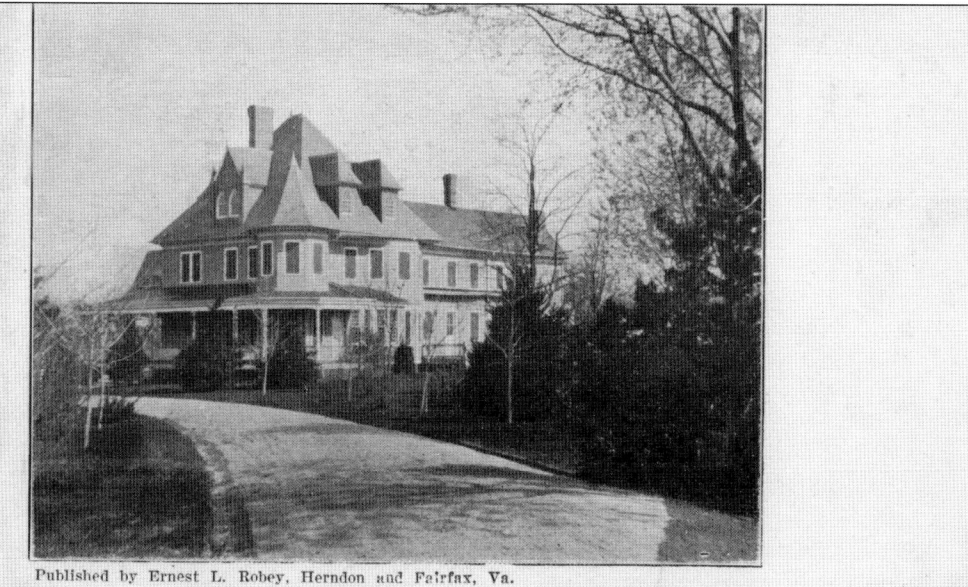

Published by Ernest L. Robey, Herndon and Fairfax, Va.
COL. JOSEPH E. WILLARD'S RESIDENCE, FAIRFAX, VA.

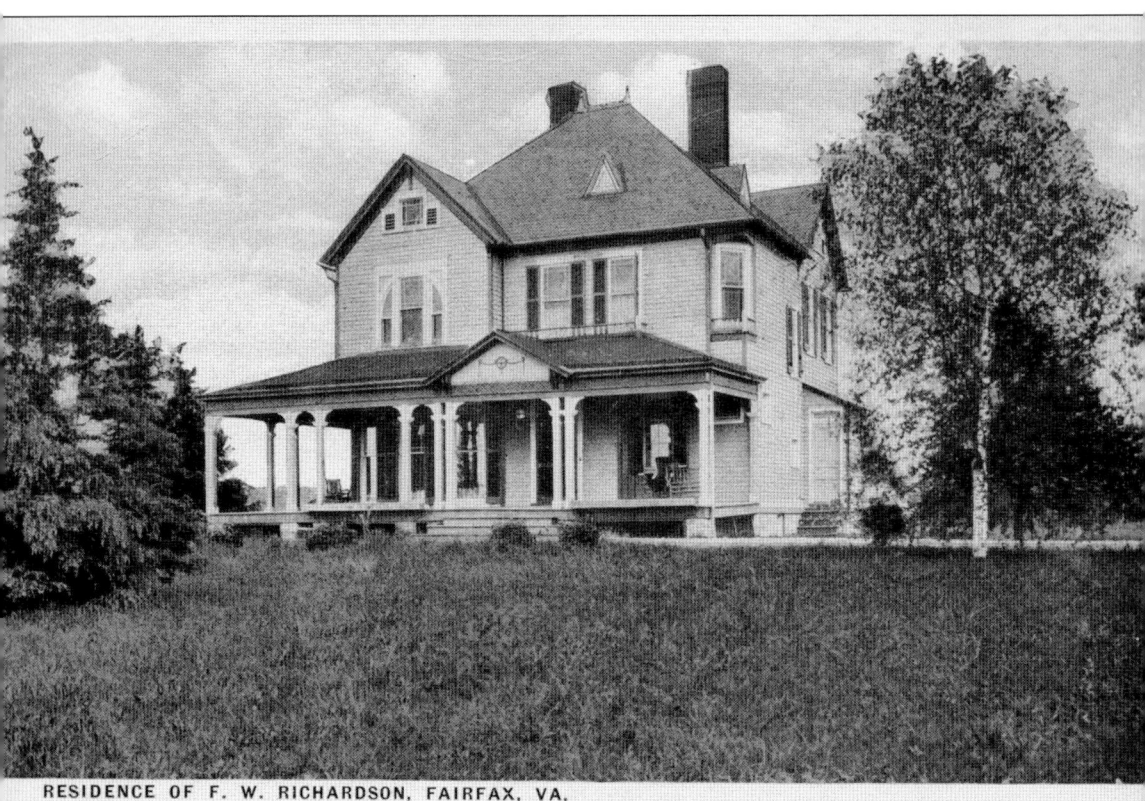

RESIDENCE OF F. W. RICHARDSON, FAIRFAX, VA.

RESIDENCE OF F. W. RICHARDSON. Above, one can see the residence of lawyer Frederick Dawson Richardson. Both his father and his grandfather had served as clerks of court for Fairfax County. Collectively, they had served the county for 104 consecutive years. Richardson established a law practice in the town of Fairfax in 1908. Richardson was a member of the county Democratic party and in 1916 was appointed commissioner of accounts for Fairfax County. He continued to practice law and reside in the county until his death in 1954. (Courtesy of the Randolph H. Lytton Historical Postcards of Fairfax.)

Two
Military History

Fairfax County has played a vital role in the nation's military history. It was the site of several decisive Civil War battles and has been home to leading army training facilities for the past 100 years. This chapter begins with a monument to the first Confederate officer killed in the Civil War. From there, much of the chapter focuses on the history of Fort Belvoir, originally referred to as Camp A. A. Humphreys. Most of the postcards about Fort Belvoir were created for and sold to soldiers to communicate with loved ones at home.

COL. MARR, CONFEDERATE MONUMENT, FIRST SOLDIER KILLED IN CIVIL WAR, FAIRFAX, VA.
PUBLISHED BY ERNEST L. ROBEY, HERNDON AND FAIRFAX, VA.

COLONEL MARR, CONFEDERATE MONUMENT, C. 1904. Dedicated in 1904, the Marr Monument was erected to honor Capt. John Quincy Marr. Marr graduated second in his class at the Virginia Military Institute in 1846. Before the Civil War, he served as county treasure, sheriff, and a justice of county courts. Marr organized the Warrenton Rifles militia in 1860. He was commissioned a lieutenant colonel in the Confederacy in May 1861. On June 1, 1861, Marr was killed in a skirmish defending the Fairfax County Courthouse, making him the first Confederate officer to be killed in the Civil War. He was buried in the Warrenton Cemetery. This monument can be found outside the Old Fairfax Courthouse. Adjacent to the monument are two Confederate cannons pointing north.

Fairfax, Va. Monument to Fairfax Soldiers who died in Service in the World War

Camp A. A. Humphreys: Pitching Shelter Tents. Camp A. A. Humphreys was quickly established in 1918. Built alongside an engineering school the army had established on the site in 1915, the camp was used to train and mobilize U.S. forces for World War I. The entire facility was completed in 11 months. The rapid transformation turned a sleepy farming community into a bustling military complex in less than a year.

Camp A. A. Humphreys: Barracks Buildings. The rapid construction of the camp displaced several homes and farms. Five thousand soldiers and 6,000 civilian workers built the camp over the course of 11 months. Much of the most difficult work was completed by segregated, all-black, service battalions.

PARADE GROUNDS, CAMP A. A. HUMPHREYS, VA.

Camp A. A. Humphreys: Parade Grounds. This card shows soldiers organized on the Camp A. A. Humphreys Parade Grounds. In the distance, one can see the water tower and much of the rest of the camp. Most of the quickly built buildings in the distance were torn down in the interwar period. Eventually, the buildings were replaced by more permanent stone structures.

Social Room, Y. M. C. A. Hut, Camp Humphreys, Va.

CAMP A. A. HUMPHREYS: SOCIAL ROOM. The Knights of Columbus, the Jewish Welfare Board, the Red Cross, the YMCA, and the library board were each permanent fixtures of life at the camp. In this shot, one can see soldiers spending time in the YMCA social room. On the back of this particular card, a young recruit noted that this room was also where they received their mail.

Y. M. C. A. Administration Bldg., Camp Humphreys, Va.

CAMP A. A. HUMPHREYS: YMCA ADMINISTRATION BUILDING. The YMCA and other charitable organizations also provided various educational services to soldiers in training. Some soldiers took classes in basic reading and writing, while others learn to speak French, and others took dance lessons. The YMCA also arranged trips for soldiers to visit Washington, D.C.

CAMP A. A. HUMPHREYS: RECREATIONAL GAME. This postcard shows soldiers taking some time to play games on the parade fields. Many of the cards from this set of postcards from Camp A. A. Humphreys show these social scenes. These cards, sold to soldiers to send back to family members, focus attention away from the preparation for the impending danger of war. Notice the rifles set aside in the left corner of the postcard; many of these scenes still provide visual reminders of soldiers preparing for war.

CAMP A. A. HUMPHREYS: IN LINE FOR MESS. This card shows a long line at the mess hall. Behind the soldiers is an example of one of the 790 quickly constructed wood-framed buildings that made up Camp A. A. Humphreys. Only four months into the camp's construction, it was already in heavy use; as soon as a building was finished, it went into service preparing and mobilizing soldiers for war.

TRENCH RAILROAD, CAMP A. A. HUMPHREYS, VA.

CAMP A. A. HUMPHREYS: TRENCH RAILROAD. Before World War I, the primary means of transportation from Washington D.C. to the camp had been by boat on the Potomac. The first transportation upgrade came in paving the Washington-Richmond Highway and connecting the camp to the highway via a plank road. Railways followed shortly thereafter. These projects provided better access to the camp and hands-on training opportunities for camp engineers.

AIRING COTS, CAMP A. A. HUMPHREYS, VA.

Camp A. A. Humphreys: Airing Cots. Several soldiers sit outside the barracks as they air out cots. This card is a bit curious. The rest of the cards from the base tend to show large social scenes, recreational activities, buildings, or large shows of soldiers in uniform. The subject of this card is distinctly different from the others.

Rifle Range, Camp Humphreys, Va.

CAMP A. A. HUMPHREYS: RIFLE RANGE. In 1917, the camp acquired additional land by purchasing and condemning 14 farms between the Accotink and Pohick Creeks. This parcel of land was turned into target ranges. The following year, the camp purchased an additional 3,300 acres. The area is now home to Davidson Army Airfield.

CAMP A. A. HUMPHREYS: AMPHITHEATER. This card offers a good view of the truly massive scale of Camp A. A. Humphreys, as well as the massive scale of the U.S. mobilization effort for World War I. The full plans for the camp anticipated the accommodation of approximately

20,000 servicemen. At the end of the war, the camp had provided training for more than 50,000 people.

Cleaning Up, Camp Humphreys, Va.

CAMP A. A. HUMPHREYS: CLEANING UP. When the war ended in November 1918, the camp served as a center for demobilization of the armed services. Within a year, more than 14,000 men were discharged at the site. In the image above, Many of the men are clearing and cleaning out the camp. While many military installations contracted after the war, Humphreys actually expanded. By 1919, the camp had quadrupled in size to 6,000 acres. During that year, the army relocated its school of engineering to the base.

FORT BELVOIR: SECTION OF ENGINEERING REPLACEMENT CENTER. With the start of the Second World War, a whole new round of construction was necessary to make room for another major influx of draftees. After 1940, the base acquired an additional 3,000 acres, which made room for the Engineering Replacement Training Center pictured above. The fort remained the home of the U.S. Army's Engineering School until 1988.

FORT BELVOIR. In 1935, Camp A. A. Humphreys became Fort Belvoir. The name change pays homage to the historic land the fort occupies. Much of the fort's current area was originally part of William Fairfax's 1730s Belvoir Manor. Col. Edward H. Schulz's 1931 excavation of the plantation's ruins at the fort helped to bring the history of the area into the consciousness of decision makers.

49

No. 575 ENGINEERS CONSTRUCT HEAVY PONTOON BRIDGE—FORT BELVOIR, VA.

BRIDGE CONSTRUCTION AT FORT BELVOIR. Many of the Fort Belvoir cards celebrate some of the feats of engineering undertaken by Belvoir engineers. These postcards show engineers constructing a pontoon bridge and a steel bridge. The fort has a long history of being a training facility for engineers. Before World War I, in 1912, the War Department acquired the original land for Fort Belvoir as a summer camp for engineering troops stationed in Washington. The many postcards that present engineers at work communicate some of the pride these men took in their accomplishments and the value the U.S. Army placed on their work.

No. 576 Laying the flooring on a 10-H Steel Bridge—Engineer Training Center—Fort Belvoir, Va.

No. 574 DEMOLITION SQUAD DEMONSTRATES EXPLODING OF LAND MINES—FORT BELVOIR, VA.

Fort Belvoir Demolition Team. Juxtaposed against images of engineers as builders, the same set of postcards provides a shot of a demolition squad hard at work. This destructive work led to much the same goal as the constructive bridge-building projects above. Both were essential to providing paths for the army.

TRENCHES, Camp American University, Belvoir, Va.

BUILDINGS AT FORT BELVOIR. The original, hastily constructed, wooden buildings at Fort Belvoir had already begun to deteriorate by the 1920s. They were demolished and replaced with the brick Georgian Revival–style buildings pictured here. These much more substantial buildings still make up much of the current fort.

No. 1902 Topographic Division, Engineers School, Fort Belvoir, Va.

No. 1900 Post Headquarters, Fort Belvoir, Va.

FORT BELVOIR STONE BUILDINGS. Here one can see another example of the Georgian style in the stone buildings built to replace the wooden structures. Notice how the right and left wings of the building are exact mirror images.

Fort Belvoir Commanding Officer's Quarters. These commanding officer's quarters were built in 1935. The building draws on the Georgian style of architecture found in historic residences, like George Mason's Gunston Hall. Notice the symmetrical placement of windows, a hallmark of the style. The back of the residence has a two-story porch.

Three

HISTORIC TOWNSCAPES

The last 150 years have witnessed the landscape of Fairfax County transformed from a bucolic outpost to a dynamic, bustling set of connected communities with over 1,000,000 people. This section presents a history of that transformation. The chapter includes several postcards created to promote individual towns, Herndon, Clifton, Vienna, and the city of Fairfax. Across these communities, the chapter presents various public services, including railroads, post offices, school buildings, and a series of postcards created to celebrate the Fairfax County Courthouse. The chapter also includes a variety of cards celebrating various local businesses.

THREE VIEWS OF CLIFTON BUCKLEY BROTHERS, C. 1906. This card shows three views of Clifton: the town's hotel, a scene along Bull Run, and a view down Main Street. By the early 20th century, the town of Clifton had practically reached its current size. In 1902, Clifton was incorporated by act of the General Assembly, making it one of the first towns in the county.

MY OLD CABIN HOME. While there are many cards commemorating the homes of famous Fairfax County residents, this is the only one in this collection where the home is not attributed to an individual. This card represents a different kind of nostalgia. The subjects and home are unknown, and the card communicates a message of rustic, humble beginnings.

ELDON STREET LOOKING WEST, HERNDON, VA.

GREETINGS FROM HERNDON. Incorporated in 1879, the town of Herndon can be found at the northwestern corner of Fairfax County. The settlement was named Herndon in 1858. By naming the buildings on the card, this sender provided valuable information. Built in the early 19th century, the mill at the center of this postcard was one of the town's first buildings. In 1860, the Alexandria, Loudoun, and Hampshire Railroad connected Herndon into the growing rail network surrounding Washington, D.C. The rail connection helped the town develop into a hub for dairy farming and a vacation spot for D.C. residents. Many of these buildings burned down in a fire on March 22, 1917.

Friendly Greetings from Herndon

I count each hour that I'm away;
I'm looking forward to that day
When happy-hearted I'll be found,
My journeys o'er and "Homeward Bound."

57

Published by Ernest L. Robey, Herndon and Fairfax, Va.
GENERAL WASHINTON'S HEADQUARTERS NEAR DRANESVILLE, VA.

COLEMAN'S ORDINARY, C. 1907. Coleman's Ordinary, or tavern, was established in the 1740s. George Washington was a frequent visitor on his travels. Richard Coleman, the tavern owner, died in 1763. The tavern was left to his son, James, who later led the Loudoun Militia in the Revolutionary War. The tavern exists today as the Dranesville Tavern. The site can be rented through Fairfax County's historic properties services.

Millard's Mill, Colvin Run, Va. Built 1794

COLVIN RUN MILL, C. 1910. The Colvin Run Mill was built in 1811 on the site of an older mill. Most likely, the 1794 date printed on the postcard refers to this older mill. This mill is the sole surviving example of Oliver Evans's automated processes for milling in the greater Washington area. In the 1930s, the mill was abandoned. In 1972, it was restored, and it is currently managed by the Fairfax County Park Authority.

POST OFFICE AND ELECTRIC RAILWAY STATION, VIENNA. This postcard shows Vienna, Virginia's early post office and rail station. Often referred to as the Freeman House, this building was constructed in 1859. It has served a variety of purposes in the history of Vienna. The building has operated as a rail stop for the Washington and Old Dominion Railroad, as a hotel, as a hospital during the Civil War, and as the town post office. The Freeman House is now a museum and general store. It is open to the public on weekends.

COURT HOUSE, FAIRFAX, VA. BUILT IN 1800.

FAIRFAX COUNTY COURTHOUSE ESTABLISHED. The original Fairfax County Courthouse was established in Alexandria in 1752. By the late 18th century, George Mason and other political leaders felt that the proximity of Alexandria politicians to the courthouse was providing them with too much power in local politics. In 1798, the Virginia General Assembly required the county to move the courthouse to a more central location. Carpenter John Bogue was hired to build this new courthouse in 1799. Located at the intersection of the Little River Turnpike and Ox Road, the building was constructed on land donated by Richard Ratcliffe. Completed in 1800, the courthouse brought considerable growth to the surrounding town, then known as Earp's Corner. In 1805, the Virginia General Assembly changed the name of the community to the town of Providence.

FAIRFAX COURT HOUSE.

FAIRFAX COURT HOUSE—More Than 110 Years Old.

The Providence Courthouse through the Civil War. In May 1861, the Fairfax County delegation to the state's convention voted for secession from the Union. Just 15 miles outside the nation's capital, the Fairfax County Courthouse had been declared a seat of local government for the Confederacy. The courthouse became a point for repeated conflict over the course of the war. On June 1, 1861, John Quincy Marr became the first Confederate officer to die in the Civil War. He died near the courthouse and is commemorated in a monument placed on the northeastern corner of the grounds. After victory at Bull Run, the Confederacy made the Fairfax County Courthouse into an outpost to watch Union movements. In 1862, the Confederate forces abandoned the courthouse for fortifications in Centerville. From 1862 until the end of the war, Union troops controlled the courthouse. During that time, Confederate guerilla fighters routinely attacked it. By the end of the war, the building had suffered significant damage.

The Old Court House Well, Fairfax, Virginia

FAIRFAX COUNTY COURTHOUSE RENOVATED AND EXPANDED. The original Fairfax County Courthouse is still used today. These postcards show the building before and after several major additions. The original section now makes up the northern wing of the larger court building. The courthouse was first expanded in the 1930s and again in 1951. The 1951 expansion included the new center block and wing. The addition to the old courthouse is so well balanced that most people passing by never notice a distinction between the old and new sections of the building. The old courthouse currently functions as the Fairfax Juvenile Domestic Relations General District Court and Clerks Office.

62

Old Section, FAIRFAX COURT HOUSE, FAIRFAX, VA.

CLOSER VIEWS OF FAIRFAX COUNTY COURTHOUSE EXPANSION. Here one can see a zoomed-in view of the old section of the courthouse after the addition shown in the previous images. After substantially expanding the courthouse in the 1950s, the Town of Fairfax incorporated to become the City of Fairfax. According to the structure of Virginia government, this placed the city of Fairfax outside of the county and with it, the many county government buildings. In 1967, the county invested a significant amount of money in restoring the old section of the courthouse to its original layout. In the 1970s, the county constructed a much larger judicial center a few blocks away, but the old courthouse continues to operate as part of the county's facilities. (Below courtesy of the Randolph H. Lytton Historical Postcards of Fairfax.)

NEW SECTION OF OLD FAIRFAX COURT HOUSE, FAIRFAX, VA.

PUBLIC SCHOOL BUILDING, FAIRFAX, VA.

PUBLISHED BY ERNEST L. ROBEY, HERNDON AND FAIRFAX, VA.

PUBLIC SCHOOL BUILDING, 1912. Fairfax Public Elementary School was constructed in 1873, one year before the community was renamed the town of Fairfax. The building cost $2,750 to build, a considerable sum of money at the time. The bricks for the building were made from a clay pit across the street. The front entryway was added in 1912. The school served as the primary educational facility for the area until 1925, when a larger facility was constructed. The building currently houses the Fairfax Museum and Visitor Center and is listed on the National Register of Historic Places.

High School, Herndon, Va.

HERNDON HIGH SCHOOL. Herndon High School opened its doors to students in 1911. By 1930, the school had 71 students. It was the first school in the county to boast its own school cafeteria. The cafeteria opened in 1942. In the 1950s, the school building was expanded to accommodate more students. In the 1960s, the high school was moved to another location, and this building became the Herndon Intermediate School.

"WILLARD HALL." FAIRFAX, VA.

OLD TOWN HALL OR WILLARD HALL. This neoclassic building was financed by politician Joseph E. Willard and constructed by local builder Arthur Thompson. When the building was finished in 1900, Willard offered the hall to the people of Fairfax. Over the last 100 years, the hall has served as a meeting place for the American Legion and a place for various public events. In 1911, many Fairfax residents paid 10¢ to see their first motion picture projected in the hall. The City of Fairfax and Historic Fairfax City, Inc., renovated the building in 1987. The second floor of the building is now home to Fairfax Art League. It also serves the community as a place for weddings and other gatherings. (Below courtesy of the Randolph H. Lytton Historical Postcards of Fairfax.)

FAIRFAX COUNTY LIBRARY. This postcard from the 1950s shows one of the county's many libraries. The county currently has 22 different libraries serving residents. In addition to providing a wide range of books and other materials to residents, the branch in Fairfax City houses an extensive collection of resources on Virginia history.

CHAS. F. BROADWATER HARDWARE STORE. Charles Fox Broadwater ran a variety of businesses over his lifetime in Fairfax. His store, Chas. F. Broadwater's, sold a wide range of hardware, as well as parts for wagons and buggies. While most cards in this collection show photographs of the establishment, this card is illustrative of a more economical alternative. Shop owners like Charles, who wanted to promote their work, could choose from a variety of stock images that would then be used to create a customized postcard.

67

Published by Ernest L. Robey, Herndon and Fairfax, Va.
ELECTRIC DEPOT, FAIRFAX, VA.

Electric Depot. In 1904, the Washington, Alexandria, and Mount Vernon Railway extended service to the Fairfax County Courthouse. This rail line provided easy access to D.C. for the community emerging around the courthouse. By 1906, the network of electric trains had carried more than 1.5 million passengers on its 92 daily trains. The network was expanded to connect with Camp A. A. Humphreys during World War I. The system fell into decline with the emergence of widespread car ownership. In 1932, the last trains carried passengers across the system. (Courtesy of the Randolph H. Lytton Historical Postcards of Fairfax.)

Published by Ernest L. Robey, Herndon and Fairfax, Va.
DRUG STORE AND HALL, FAIRFAX, VA.

DRUG STORE AND HALL. The image above shows Ernst L. Robey's drugstore and hall. During the first 30 years of the 20th century, Robey owned several different drugstores, one in Herndon, one in Washington, D.C., and this one, near the Fairfax County Courthouse. Many of the postcards discussed in this book, including this one, were created by Robey for sale in his stores. Beyond working as a druggist, Robey was also a Freemason, a member of the Herndon Congregational Church, and a member of the chamber of commerce, and from 1901–1910, he served as the director of the Peoples National Bank of Leesburg. (Courtesy of the Randolph H. Lytton Historical Postcards of Fairfax.)

Main Street, Fairfax, Va. The Old Little River Pike over which Stage Coaches ran before the days of railroads.

MAIN STREET, FAIRFAX. The city of Fairfax's Main Street has been a major thoroughfare in the region since before the American Revolution. Much of the road follows pre-Colonial Native American trails. During the 18th and 19th centuries, the street was part of the Little River Turnpike, which operated as a toll road from Alexandria to Aldie. The intersection of the turnpike and the Chain Bridge Road provided a compelling location at the center of the county for construction of the new courthouse in 1800. The construction of the courthouse at this location was instrumental in the creation and growth of what would eventually become known as the city of Fairfax.

Main St., Fairfax, Va.

HERNDON RAILROAD STATION. The 1857 arrival of the railroad in Herndon was instrumental to the development of the town. With the arrival of the trains came a demand from residents for a post office, which in turn required a name for the community. One of the residents suggested the town be named after Capt. William Lewis Herndon. Years earlier, the resident had escaped a sinking sidewheel ship that Captain Herndon piloted through a hurricane off the coast of the Carolinas. Captain Herndon went down with the ship. On July 13, 1858, the rail station became an official post office for the town of Herndon. The station closed in 1968. The building is now a museum focusing on the history of Herndon.

RAILROAD STATION, HERNDON, VA.
Published by Ernest L. Robey, Herndon and Fairfax, Va.

Old Dominion Station, Vienna, Va.

Old Dominion Station, Vienna. The Old Dominion Station in Vienna, Virginia, was part of the intrastate short-line railroad system known as the Washington and Old Dominion Railroad, often referred to as the W&OD. The route provided easy means to get from many parts of the county into the nation's capital. Much of the system is now a trail for hiking and biking.

FAIRFAX HIGH SCHOOL. These postcards show the original Fairfax High School building. Constructed in 1936, the building is located on Lee Highway on the western edge of the city of Fairfax. This building housed the city's high school students until 1972, when the new Fairfax High School was constructed. The building then transferred ownership to George Mason University and then to the Catholic Diocese of Arlington, which turned the building into Paul VI Catholic High School. For the first three years of the Catholic school's operation, one wing of the building was used as housing for Alzheimer patients. The building continues to house the Paul VI Catholic High School.

HANSBROUGH SUBDIVISION. Built in the late 1950s, the Hansbrough Subdivision is illustrative of rapid suburban growth throughout the county. Since 1970 alone, the population has more than doubled from 450,000 people to over one million. The subdivision is located just north of Route 123, near McLean Central Park.

Seven Corners Market. The Seven Corners area's name comes from the close intersections of five roads that create seven street corners: Leesburg Pike, U.S. Route 50, Wilson Boulevard, Sleepy Hollow Road, and Hillwood Avenue. This area became a major crossroads in 1809, when the Columbia Pike, then called the Washington Graveled Turnpike, intersected with the much-older Leesburg Pike.

The Occoquan Bridge Occoquan, Va.

Occoquan Bridge. The Occoquan Bridge connects Fairfax County to the city of Occoquan in Prince William County. Established in 1804 by Nathaniel Ellicott, Occoquan retains much of its historic character. In 1972, Hurricane Agnes destroyed a considerable amount of the town, including what remained of the Occoquan Iron-Truss Bridge. The bridge has since been restored.

GREETINGS FROM VIENNA. Originally called Ayr Hill, the town was renamed "Vienna" in the 1850s, when William Hedrick, a doctor, offered to move to the community if it would be renamed after the town he had grown up in, Vienna, New York.

VINCENT'S STORE AND SERVICE STATION. Vincent's Store and Service Station sold gas and snacks to travelers passing through the city of Fairfax. The back of the card includes information about the construction of the county courthouse, located a mile away, in 1799.

Routes 29-211-50 — Junction of 123 & 211
FAIRFAX, VIRGINIA

THE 29 DINER. Serving up traditional diner fare since July 20, 1947, the 29 Diner was added to the National Register of Historic Places in 1992. Architectural historian Marc Christian Wagner suggests the diner's significance as the following: "While it is rare to find one of these 1940s diners still standing, it is even more unusual to find one still in operation. The high quality of this Mountain View diner has withstood the test of time in a hostile environment." It remains a favorite spot for both hungry college students and diner aficionados. (Courtesy of the Randolph H. Lytton Historical Postcards of Fairfax.)

Streamliner Restaurant
U. S. Routes 50-29-211 — ½ Block West of Fairfax Circle
FAIRFAX, VIRGINIA

STREAMLINER RESTAURANT. Run by Bob Parcelles, who had previously managed the 29 Diner in the early 1950s, the Streamliner Diner operated from the early 1960s until it closed in 1985. On this spot, one can now find Mama's Restaurant.

AERIAL VIEW, CITY OF FAIRFAX, 1947. Founded in 1805 and originally named Earp's Corner, the city of Fairfax became an independent city in 1961. The growth of the city was directly connected to the placement of the county courthouse at the heart of the community in 1800.

The Tavern, Fairfax, Va. Built earlier than 1800. A famous hostelry in the old Stage Coach Days.

THE TAVERN, C. 1919. The back of the card reads: "A clean, comfortable, commodious, Country Colonial Inn, located in beautiful and historic Fairfax Va., 20 miles by trolley from Washington D.C. A home-like, delightful resort for week's end, month's end or season's end. George Washington lived and died in Fairfax County. His will and that of Martha Washington can be seen in the Clerk's Office at this place."

GENERAL MOTORS TRAINING CENTER. Above you can see one of 30 training centers General Motors constructed across the country during the 1960s. This particular facility was located at 10355 Lee Highway in the northern part of the city of Fairfax. The back of the card reports that the building had "modern classrooms and workshops, an auditorium, conference room, and other areas, all specially equipped to provide the automotive industry's finest facilities for improving and extending the skills of experienced service men." Furthermore, that "training centers are staffed by expert teachers and supplied with the newest tools and training aids to assure the most competent instruction in new methods of maintenance and repair. "

W. T. Woodson High School. Since 1962, Wilbert Tucker Woodson High School has served residents just east of the city of Fairfax. When the school opened, it was the largest in the state of Virginia. The original cost of the facility was $3.3 million. The building features a planetarium, and along with its general high school course offerings, it boasts a vocational training wing with classes in cosmetology, carpentry, veterinary science, and electricity. The school was named after the superintendent of schools who had just stepped down in 1961. Woodson High School continues to offer a high quality education to its students, and it is frequently voted as a top school in nationwide rankings, along with several other area schools.

The Fairfax County Judicial Center. The Fairfax County Judicial Center underscores the nearly exponential growth of the county. The comparison of the original courthouse images to those after expansion and of this massive judicial center provides a particularly clear illustration of the county's move from small community to sprawling social and commercial center. Finished in 1982, the judicial center houses the Fairfax Circuit Court and Clerks Office, the General District Court and Clerks Office, Office of the Commonwealth's Attorney, the Fairfax Bar Association and Law Library, and the Sheriff's Office. Since the 1980s, the center has expanded considerably to make additional room for county services.

AERIAL VIEW OF RESTON, GULF RESTON PHOTOGRAPH, C. 1970. Established on April 20, 1964, the community of Reston was the first post-war planned community in Fairfax County. The community gets its name from the initials of its creator and planner, Robert E. Simon. Simon purchased the 7,300 acres of land the community was built on from Smith Bowman, who operated a bourbon distillery and farm on the site.

RESTON LAKEVIEW CLUSTER TOWNHOUSES, GULF RESTON PHOTOGRAPH, C. 1972. Lake Anne Plaza was the first section of the community to be developed. This community mirrors decisions made throughout the town. High-density housing was employed to conserve open spaces, leaving considerable space for meadows, streams, and common grounds.

PLAZA AT RESTON, GULF RESTON PHOTOGRAPH, C. 1972. Each section of Reston is connected to the plaza, where locals can find restaurants and shops. As part of the design of this particular community, there are no chain stores or restaurants allowed.

THE VIRGINIAN. The Virginian is a private, nonprofit, nondenominational retirement community located northeast of the center of the city of Fairfax. The building was finished in 1980 and is located on 32 acres of land. It continues to operate today. The large building's boxy style is indicative of the blocky contemporary buildings that have dominated new construction across the county for the last 30 years. For another example of this style of architecture, see the Fairfax County Judicial Center. (Courtesy of the Randolph H. Lytton Historical Postcards of Fairfax.)

FAIRFAX FURNITURE, INC. Here is a shot of Fairfax Furniture, Inc. This business was located across the street from Fairfax High School. According to the back of the card, they offered "distinctively different, Colonial, Traditional and Modern Furniture." They also noted that they had "Parking for 50 cars, showroom completely air-conditioned." (Courtesy of the Randolph H. Lytton Historical Postcards of Fairfax.)

COMMONWEALTH DOCTORS HOSPITAL. Built in the 1960s, the Commonwealth Doctors Hospital is still located on Chain Bridge Road, just south of the city of Fairfax. It is now part of a much more extensive facility. The back of the card presents the hospital as "a new proprietary modern facility owned by the public, built with private initiative, in response to the growing health need of the Northern Virginia community." The aerial view of this card also provides an excellent record of development on the southern side of the city of Fairfax in the 1960s.

TOWER HOUSE ON THE POTOMAC. Located near Mount Vernon and overlooking the Potomac, the Tower House was built as part of a small plantation. The property was originally part of George Washington's estate. In 1909, the house's then-owner, Doctor Bliss, lost the home and surrounding property in a game of poker in the nearby boathouse. During World War I, the house was used as a convalescent hospital for troops returning from the front. After the war, the building served as an administrative office for the Baraca Philathea Union Bible Class organization, started by Marshall A. Hudson. The building is now part of the Historic Cedar Knoll Inn.

Four

RECREATION

Fairfax County has long boasted exceptional parks and recreation. This chapter provides a glimpse into the history of recreation in the county. The chapter includes a significant set of postcards presenting the history of Great Falls National Park. It also charts changes in the manner in which visitors traveled and stayed in the Fairfax region through the history of camps, motels, and hotels. The history of tourism and travel, visible through the cards presenting roadways, restaurants, camps, motels, and hotels, provides a compelling parallel to the history of the county's development, present in the previous chapter on the its historic townscapes.

Bull Run, Va.—Negro Boys Bathing in Bull Run Creek

BULL RUN CREEK. Bull Run Creek marks a significant portion of the border between Fairfax and Prince William Counties. Bull Run is most well-known for the two major Civil War battles that occurred nearby. This card illustrates the creek's role in fun and recreation.

GREAT FALLS, VA.
Published by D. H. Naramore, 3141 M St. N. W. Compliments of Great Falls & Old Dominion R. R. Co.

Don't fail to see the Great Falls of the Potomac. 25 cents round trip including transfer through city on return. Cars every 30 minutes, 36th and M Sts.

GREAT FALLS. Great Falls Park has been a popular tourist destination for more than 100 years. The 800-acre park is home to over a hundred species of birds as well as deer, fox, chipmunks, and squirrels. George Washington owned a significant amount of land in the area and was involved in a large canal project there. The earliest signs of habitation in the Great Falls area date back to 10,500 B.C.E. When Europeans first visited the Americas, the area served as a meeting ground for peoples of the Powhatan Confederacy and the Iroquois Nation. The falls are a stunning example of the beauty and power of nature.

GREAT FALLS OF THE POTOMAC

George Washington Memorial Placed by The D. A. R. at Great Falls, Va.
15 miles from Washington, D. C. on the Wash. & O. D. R. R.

George Washington Memorial Plaque At Great Falls. This memorial commemorates George Washington's involvement in the history of the Great Falls area. In the 1780s, Washington was involved in promoting and partially funding the Patowmak Canal, a bypass of the falls that made the Potomac navigable beyond them. The ultimate goal of this project was to create a navigable seaway far into the interior of the United States.

THE FLOOD, GREAT FALLS PARK, VA., 91 FEET ABOVE NORMAL

GREAT FALLS FLOODS. Several major floods of the Potomac have made significant impacts on Great Falls and the surrounding area. This postcard shows the aftermath of the 1889 flood. To put the flood in context, the nearby Great Falls Tavern's entire first floor was filled with water. One of the lasting impacts of the flood was the destruction of the canal George Washington had helped envision and implement.

Dining Pavilion at Great Falls of the Potomac, 15 miles above Washington, D. C., on G. F. & O. D. R. R.—(316)

DINING PAVILION AT GREAT FALLS ON THE POTOMAC. Great Falls has been a tourist attraction for more than 100 years. Here one can see an example of the amenities tourists had available to them in bygone eras. Notice the style of the structure. It is the same type of building in the previous image of the aftermath of the flood of 1889.

Massive Masonry Lock of Canal, built by George Washington at Great Falls, Va., 15 miles from Washington, D. C., on G. F. & O. D. R. R.—(318)

MASSIVE MASONRY LOCK BUILT BY GEORGE WASHINGTON AT GREAT FALLS. Here is part of the remains of the Patowmak Canal. Completed in 1802, the Patowmak Canal Company operated for the next 26 years. The canal raised and lowered boats along the falls, allowing shipping to extend much further along the Potomac. Some of the canal's ruins are still visible in the park grounds today.

Government Dam, Great Falls of the Potomac, Maryland. 15 miles from Washington, D. C.

GREAT FALLS DAM. The Great Falls region of Fairfax has a significant history of floods. In the aftermath of the floods of 1936 and 1937, the Army Corps of Engineers planned to construct a series of dams to regulate the Potomac. Only one of the dams, pictured here, was ever constructed. The Army Corps of Engineers planned a much grander series of dams on tributaries, as well as a much larger dam near the falls that would have backed up the river all the way to Harpers Ferry. These more ambitious plans met significant criticism, most notably from the Supreme Court justice William O. Douglas. In the end, this was the only piece of the plan to be constructed.

Great Falls of the Potomac near Washington, D.C.

Scenic Tower at Great Falls, Va., on W. & O. D. Ry.

GREAT FALLS NATIONAL PARK. Great Falls became a national park by act of Congress in 1930. When it became a park, the area still had an amusement park, a rail line connecting the park to D.C., and a power plant on the grounds. The amusement park went out of business in 1956. When the National Park Service took control of the area in 1966, they leased the area owned by the power company. The park is part of the northern area of the George Washington Memorial Parkway, which connects many of the historic places from Washington's life. Since the 1960s, the National Park Service has put significant resources into archeological work and restoration on the canal and the ruins of Matidaville, a former city now within the 800 acres park.

THE PATH TO "DICKIE'S LANDING," GREAT FALLS OF THE POTOMAC, 15 miles from Washington, D. C., on G. F. & O. D. R. R.—(321)

PATH TO "DICKIE'S LANDING" AT GREAT FALLS OF THE POTOMAC. This postcard offers a view of some of the paths and trails that still wrap around Great Falls Park. Today the park offers visitor's trails for hiking and biking, spots for bird watching, places for rock climbing, fishing, horseback riding, and picnicking. A visit to the park makes it readily apparent why George Washington loved the area and why it has been such a popular destination for tourists for over 100 years.

Winter Marshall R.M. Kivett Vernon Wright

G.B. Wright Mr. C.H. Wine, Sr. "Grandpap" McHugh

PERSONAL POSTCARDS. Among this entire collection, the personal photographic postcards pictured here are unique. Campbell's Virginia Beach Postal Studio created the card at left around 1910. The back of the card requests that it be returned to Helen E. Buckley, who lived in the historic Buckhill residence in Clifton. It would appear that she has identified the various illustrious men of Clifton on the front of the postcard. The card below preserves a resident and his proud catch. Printed in much smaller runs, cards like these show another role that postcards played as personal keepsakes to share proud moments with friends and family.

A 23½ pound Cat Fish caught near Occoquan Bridge
by C. C. Groseclose of Herndon, Virginia.
Picture taken by H. F. Jennings, 1942

Greetings from ACCOTINK, VA.

GREETINGS FROM ACCOTINK, C. T. AMERICAN ART 1920S POSTCARD COLLECTION. The U.S. federal government purchased the Accotink Park region in 1912. Much of what is now the park was part of the William Fairfax's Belvoir Estate. The rest of the estate became Camp Humphreys and eventually Fort Belvoir. The Accotink Creek and marsh made the land less than ideal for military use. In 1960, the Fairfax County Park Authority began leasing the land from the federal government. Since then, Accotink Park has provided a variety of public programs and services to area residents.

PHONE 122 MEALS AT ALL HOURS

Colonial Inn

D. L. CURTIS, PROP.
"CURTIS-Y SERVICE"

CHICKEN and VIRGINIA HAM DINNERS

JUNCTION, ROUTES 211 & 50 FAIRFAX, VA.

COLONIAL INN, 1939. The Colonial Inn, located at the junction of Route 211 and Highway 50 in Fairfax, served up "meals at all hours." The back of this card makes specific note of their chicken and Virginia ham dinners. It is interesting to compare this card to those of other area restaurants. Almost all the other cards for restaurants, and for that matter most other businesses, chose to place images of their enterprises on the front of the card. In this case, the proprietor selected this scene, a few chairs pulled up near the fireplace.

500:—SCENE ON LEE HIGHWAY IN VIRGINIA.

OLD LEE HIGHWAY, ASHEVILLE POSTCARD COMPANY. Named after Robert E. Lee, the Lee Highway was created as a National Auto Trail. In its original form, it connected New York City to San Francisco. The Virginia section of the highway was established in 1922 and connected the Francis Scott Key Bridge to the border of Tennessee at Bristol, Virginia. Much of the original highway still exists.

MEET ME AT COLVIN RUN. For much of the history of the county, Colvin Run Village was the largest community on the Leesburg Pike between Falls Church and Leesburg. The small community grew from the 1890s through the first decade of the 20th century, at which point

paved roads made it easy for residents to find services elsewhere. This transformed the small village into a bedroom community for nearby cities.

Kamp Washington, Fairfax, Va.

CAMP GREEN LEAF AND KAMP WASHINGTON. Camp Green Leaf and Kamp Washington are excellent examples of the auto camps that began appearing on the outskirts of urban areas around the country in the early 20th century. Notice the road in the image from Kamp Washington and the car on the left side of the photograph. These sorts of retreats were made possible by the widespread availability of the automobile. At one point, Kamp Washington served as housing for Native American families during negotiations with the U.S. government. The development of these camps is directly tied to the national highway system that had begun to develop in the 1920s.

GREEN LEAF CAMP
22 MILES SOUTH OF WASHINGTON, D C
ON U. S. ROUTE 1

Kamp Washington. Here one can see how the owners of Kamp Washington located it in relation to what they thought were the most important features of the area. The postcard draws attention to the roadways and connects the camp to the region's most popular tourist symbols, the Capitol building in D.C. and George Washington's home, Mount Vernon.

WESTWOOD MOTEL—ON ROUTES 211, 29 AND 50—FAIRFAX VA

WESTWOOD MOTEL. After World War II, a new term entered English dictionaries: motel. Here one can see two examples of how the Westwood Motel presented itself to tourists on its postcards. According to the back of one of the cards, the motel provided a "television in every room." As "one of Virginia's newest motels," the Westwood Motel provided its visitors "modern tile baths, tubs with showers, and air-conditioning." The motel was owned and operated by Mr. and Mrs. A. L. Jones. The motel marked an interesting departure from the camp model. The car has become an even more prominent part of the design and structure.

104

HOWARD JOHNSON'S • FAIRFAX CIRCLE • FAIRFAX, VA.

"LANDMARK FOR HUNGRY AMERICANS"

FAIRFAX CIRCLE HOWARD JOHNSON. The Fairfax Circle Howard Johnson provided soft drinks, hot dogs, and ice cream to visitors and residents. By 1939, there were more than 100 Howard Johnson restaurants along East Coast highways. By the mid-1940s, only 12 of the restaurants remained, but the company rapidly rebounded after the war. As one of the first widespread franchises to make its way into the county, this Howard Johnson is an indicator of the highly franchised future the county would experience.

Manuel's Tourist Camp
On U. S. Route No. 211, 2 Miles West of Fairfax, Va., Lee Highway
Heated Cabins - Certified Water - Luncheons. Open all Year. C. Manuel, Prop.

Manuel's Tourist Camp. As tourists hit the highways, they found the need for places like Manuel's Tourist Camp to refuel their cars. The style of the building—wood siding and terra-cotta roof tiles—is illustrative of the sort of idiosyncratic styles individual owners deployed while the style and format of gas stations was still being refined. The back of the card reports that the camp was built on the "old location of Camp Lagers Cantonment where 880 officers and 22,624 soldiers were stationed during the Spanish-American War in the year of 1898."

AERIAL VIEW OF ADES CAMP COMFORT

CAMP COMFORT AND GATEWAY MOTOR LODGE. Camp Comfort and the Gateway Motor Lodge provide additional examples of the sort of camp-style hotels created for D.C. residents to escape the city and for tourists to stay at while they visited the nation's capital and the many historic sites throughout the county. These types of spots provided visitors to Fairfax their own cabin. Both camps were located near the junction of U.S. Routes 211, 50, and 29. The back of the Camp Comfort postcard promises "A home away from home. Modern cottages, lunch room, and service station." In its time, one could call Camp Comfort at Fairfax 318-W.

Gateway Motor Lodge
Hwy 211, 29 and 50
Fairfax, Va.

THE RIVER BEND LODGE. The River Bend Lodge was located on the River Farm property. River Farm was the northernmost of George Washington's five farms. The back of the postcard notes that River Bend was "famous for fried chicken and country ham dinners, lunches, sandwiches, and homemade pastries."

CITY VIEW TOURIST HOME. This elaborate residence is the City View Tourist Home. Built in 1918, the City View Tourist Home was constructed by W. Franklin P. Reid on the site of an older historic home. The observation room provided panoramic views of the Potomac, Washington, D.C., and Montgomery County, Maryland. The home was surrounded by a variety of smaller cottages for other visitors to stay in.

PENN-DAW HOTEL. The Penn-Daw Hotel's name comes from a combination of the last names of its two proprietors, Pennlyn and Dawson. The hotel provided another spot for tourists in the area to stay. Pennlyn financed the operation, and Samuel Cooper Dawson ran the establishment. Each of the buildings had four individually heated cabins. Dawson lived in the hotel and managed it for most of his life.

VIENNA INN. Located on Maple Avenue in Vienna, Virginia, the Vienna Inn has provided Fairfax residents with chili dogs and beer since it opened in 1960. The building was originally established as an ice cream parlor in 1925. While much of the county has changed and transitioned from a rural-feeling small town into a bustling community, the inn remains a touchstone to an earlier era.

GARCIA'S COFFEE SHOPPE—MOTOR COURT 6 MILES SOUTH OF ALEXANDRIA, VA.

GARCIA'S COFFEE SHOPPE AND FAIRFAX COFFEE SHOPPE, 1940s. These two cards show coffee shops that opened in the county during the 1940s. South of Alexandria, Virginia, on U.S. Route 1, Garcia's Coffee Shoppe and Motor Court offered coffee and snacks to road-weary travelers. The second shop was located near the city of Fairfax. The aerial view of Garcia's Coffee Shoppe prominently shows its location in relation to the road, drawing attention to and underscoring the role that the expansion of the highway system and availability of cars played in shaping the history and landscape of the county. These cards, sold to visitors, offer a glimpse into travel along historic U.S. Route 1 and through the city of Fairfax.

VIRGINIA LODGE. While there were many motels serving the area, few of them remain today. The Virginia Lodge, on U.S. Route 1 just south of the city of Alexandria, has been in continuous operation for more than 50 years. The motel still continues to provide visitors its air-conditioned rooms and swimming pool.

VIEW OF DYKE MARSH AND MOUNT VERNON MEMORIAL HIGHWAY, C. 1909. Dyke Marsh is a freshwater tidal wetland on the western bank of the Potomac River between Mount Vernon and Old Town Alexandria. It consists of more than 370 acres of tidal marsh, floodplain, and swamp forest. Formed more than 6,000 years ago, this marsh is the largest tidal wetland remaining in the D.C. metropolitan area. In the 19th century, a dyke built around the area protected it from shifts in the tides.

FAIRFAX SPORTS CLUB STEEPLECHASE. This postcard, commemorating a steeplechase in Reston, points to Fairfax County's long-standing traditions in horse keeping and racing. A steeplechase is a race in which jockeys take their horses through a series of jumps. Neighboring Fauquier County has hosted one of the oldest and longest-running annual steeplechases in the United States, the Virginia Gold Cup, since 1922.

DULLES INTERNATIONAL AIRPORT. Dedicated by Pres. John F. Kennedy on November 17, 1962, Dulles International Airport has acted as an international gateway to Washington, D.C. The engineering firm of Ammann and Whitney of New York designed this distinctive structure. Architect Eero Saarinen designed the airport's signature terminal building, which won a First Honor Award from the American Institute of Architects in 1966.

Five

PLACES OF WORSHIP

Some of Fairfax County's oldest structures are places of worship. This chapter provides a history of various church communities and the cards those communities created as a celebration and commemoration. The chapter starts by presenting several Anglican churches formed before the American Revolution. From there, the chapter profiles many of the denominations that proliferated after the Revolution. The postcards presented here are not meant to represent the county's contemporary religious and spiritual diversity, but rather, offer views of some of the oldest religious communities in the county. Many of these communities continue to thrive today.

POHICK CHURCH ESTABLISHED. The Pohick Church has its roots in early Anglican communities dating back to the end of the 17th century. Construction began on this specific church in 1769, and construction was completed in 1774. George Washington and George Mason both helped raise funds for the church's construction, and both were active members when services began. Virginia's 1785 Religious Freedom Act ended the commonwealth's official support for Anglicanism. The Pohick Church became an Episcopal church and was actively used as a place of worship until it was raided in the War of 1812. Over the next 30 years, the building continued to decay and fall further into disarray.

The building committee of the church was a notable one being composed of...: the Honble. George Wm. Fairfax, George Washington & George Mason Esqrs. Captn. Daniel McCarty & Mr. Edward Payne".... "Articles of Agreement" for the building of the Church were made on the 7th day of April 1769.

As we look upon these pews there rises the vision of Washington, Mason and others, whose names give an undying splendour to this church and Truro parish

POHICK CHURCH, CIVIL WAR AND BEYOND. In the 1840s, a national fund-raising effort allowed for the restoration of the Pohick Church. Only 20-some years later, during the Civil War, the church was taken over by occupying Union troops, who used the church building as a stable. During that time, Northern soldiers vandalized and looted the church. Some of the graffiti they left is still visible on the church walls. The church began hosting services again in 1874, and a major restoration project was undertaken in 1890. Listed on the National Register of Historic Places, the church is open to visitors seven days a week. It continues to offer Sunday morning services.

POHICK CHURCH, FAIRFAX CO., VA., 7 MILES FROM MT. VERNON. BUILT 1773 FROM PLANS DRAWN BY GENERAL WASHINGTON, WHO WAS A VESTRYMAN FOR 20 YEARS.

ZION EPISCOPAL CHURCH. Here you can see images of the Zion Episcopal Church. This church was constructed to accommodate the county's growing Episcopal community in the later part of the 19th century. The construction of this wooden church points to both the expansion of the Episcopal Church during the period and a change in the values of church construction. To illustrate the change in style and materials, compare this structure with the brick Truro Church, Falls Church, and Pohick Church, which all served the same Episcopal parish. The pre–Revolutionary War churches utilized heartier building materials.

THE FALLS CHURCH, FALLS CHURCH, VA.

FALLS CHURCH. The Falls Church is one of the oldest churches in the county. Designed by James Wren, this church was constructed between 1767 and 1769. It replaced the earlier 1733 wooden structure. The Falls Church area gets its name from this church. With the disestablishment of the Anglican Church after the Revolutionary War, the church was practically abandoned. It reopened in the early 19th century and hosted services until the Civil War, at which point it served first as a Union hospital and later as a stable. In 1873, the Falls Church reopened its doors, and it has been open for services ever since.

The Old Colonial Episcopal Church, Falls Church, Va.

OLD LEWIS CHAPEL. BUILT 1857.
FAIRFAX COUNTY VIRGINIA.

CRANFORD M. E. CHURCH, SOUTH

METHODIST CHURCH, FAIRFAX, VA.
Published by Ernest L. Robey, Herndon and Fairfax, Va.

CRANFORD UNITED METHODIST CHURCH, C. 1907. The first church on this site, the Pohick Church, was built in 1730. It is one of the oldest religious sites in Fairfax County. James and John Cranford were primarily responsible for the chapel's construction. This church building opened its doors to worshipers in 1857. The chapel is named for Rev. John Lewis. Reverend Lewis was an inspirational figure in the movement. By the late 19th century, the church's growth had exceeded the capacity of the chapel. The second building was constructed in 1900 and was named Cranford Memorial. In 1953, the chapel was moved a block away from its original location to join the Cranford Memorial Church building.

THE COLUMBIA BAPTIST CHURCH, 1914. The historic Columbia Baptist Church in the town of Falls Church was founded in 1856. The church was originally placed on Broad Street but was moved two blocks to its current location in 1909. The church continues to grow and thrive today.

COLUMBIA BAPTIST SUNDAY SCHOOL, WARE'S PHARMACY, 1910. This postcard shows Sunday school students outside a different building in the Columbia Baptist Church complex. The picture shows more than 100 students dressed in their Sunday best along with their school instructors.

Andrew Chapel Methodist Episcopal Church, South, Fairfax, Virginia.

ANDREW CHAPEL METHODIST EPISCOPAL CHURCH. Founded in 1854, Andrew Chapel has been a significant part of the Methodist community in Fairfax. The inside of the church was destroyed during the Civil War, when it was used to stable horses for troops stationed in the area. The interior was restored in the 1870s. In 1964, the church community constructed a much larger facility across the street. Twenty years later, the chapel was renovated. It currently serves as a multipurpose room for the church.

Bethlehem Baptist Church, Gum Springs, Va., Rev. WILLIAM TRIPLETT, Pastor.

BETHLEHEM BAPTIST CHURCH. The Bethlehem Baptist Church has played a major role in the development of Gum Springs, the oldest African American community in Fairfax County. The Gum Springs community is located near the Mount Vernon estate. Pictured above is the second Bethlehem Baptist Church building. Constructed in 1884, this building replaced the original 1865 building. The vibrant community established around this church continues to thrive today.

WESLEY M. E. CHAPEL, VIENNA, VA.

WESLEY M. E. CHAPEL, VIENNA. Founded in 1890, the Wesley Methodist Church has been a community of worship for more than 100 years. Pictured above is the original church building. The land for the building was donated to the Vienna Methodist Episcopal church by community members Orrin E. Hine and his wife, Alma D. Hine. From 1890 until 1900, Orrin E. Hine served as the first mayor of Vienna. He is also responsible for planting maple trees along Vienna's main street, Maple Avenue.

TRURO EPISCOPAL CHURCH. The Truro Church community traces its history back to the founding of the Truro Parish in 1732. The church is part of the network of pre-Revolutionary Anglican communities of worship that became Episcopal communities after the American Revolution. The original church building is pictured above. The church began to expand dramatically with Fairfax County's nearly exponential population growth in the 1950s. In 1959, the church constructed the larger building pictured in the second postcard. In 1974, the building was again expanded to meet the growing needs of the congregation. The building continues as a place of worship for Episcopalians in Fairfax.

FALLS CHURCH PRESBYTERIAN CHURCH, E. BROAD & FAIRFAX STS., FALLS CHURCH, VA.

FALLS CHURCH PRESBYTERIAN CHURCH. Falls Church Presbyterian Church has been a significant feature of the Falls Church community for more than 100 years. The first Falls Church Presbyterian Church was built in 1856. The church in these two postcards was built in 1884. The church is located at the intersection of Fairfax and East Broad Streets. This Gothic-style church building, with its distinctive tall bell tower, was the town's first stone structure. Over the years, the building has been remolded several times. At this point, about half of the original building remains. The church continues to thrive with its vibrant community of worshipers.

124

HERNDON CONGREGATIONAL CHURCH. Herndon Congregational Church was founded on March 24, 1868. Twelve Congregationalists, who had moved into the area from other states, founded the church. Most of the founding members had migrated from New England. For the first five years, until the church building had been constructed, the congregation members met in each other's homes.

INTERIOR, CHRIST CHURCH. Located in Alexandria, Virginia, Christ Church was built between 1767 and 1773. John Carlyle designed and managed the construction of this building. This illustration of the inside of the church demonstrates its Colonial style. Christ Church was frequented by George Washington and Robert E. Lee. In 1942, as part of the World Day of Prayer for Peace, Franklin Roosevelt and Winston Churchill made a visit to this historic church.

METHODIST CHURCH, HERNDON. Herndon Methodist Church began with meetings in Herndon residents' homes in 1857. This community of worshipers became a part of the Methodist Episcopal Church North in 1869. The North Methodist church met in the building shown on this postcard. It is located near the corner of Elden and Center Streets.

METHODIST EPISCOPAL CHURCH SOUTH, HERNDON. This building, the Herndon Methodist Episcopal Church South, was constructed in 1915. The Methodist Episcopal Church South was part of a separate Methodist movement from Herndon's other Methodist church. The two church communities merged in 1939. The building can be found at 655 Spring Street.

ST. TIMOTHY'S EPISCOPAL CHURCH, C. 1907. St. Timothy's Episcopal Church was founded in November 1868. Members met in each other's homes until the church was constructed in 1881. The church no longer meets in this building, which now serves as the Masonic lodge at the corner of Elden and Grace Streets in Herndon.

FAIRFAX METHODIST CHURCH, 1959. The church's community extends back to at least 1842, when a small group of Fairfax Methodists constructed a wood-framed church near the courthouse. The wood-framed church served as their place of worship from 1879 until 1956. This postcard shows the larger church building that the congregation moved to in 1956. At that time, it served a congregation of just over 1,000. The building continues to provide a place of worship for the Fairfax United Methodist community. It has been expanded three times and now houses more than 3,000 worshipers.

Discover Thousands of Local History Books
Featuring Millions of Vintage Images

Arcadia Publishing, the leading local history publisher in the United States, is committed to making history accessible and meaningful through publishing books that celebrate and preserve the heritage of America's people and places.

Find more books like this at
www.arcadiapublishing.com

Search for your hometown history, your old stomping grounds, and even your favorite sports team.

Consistent with our mission to preserve history on a local level, this book was printed in South Carolina on American-made paper and manufactured entirely in the United States. Products carrying the accredited Forest Stewardship Council (FSC) label are printed on 100 percent FSC-certified paper.

MADE IN THE USA